someone

has to set a

bad example

someone has to set a

bad example

An Anne Taintor Collection

CHRONICLE BOOKS

SAN FRANCISCO

Library of Congress Cataloging-in-Publication Data:

Taintor, Anne.

Someone has to set a bad example: an Anne Taintor collection / by Anne Taintor.

p. cm.

ISBN 978-1-4521-0309-9

1. Women—Humor—Pictorial works. I. Title.

PN6231.W6T34 2012

818'.602—dc22

2011017483

Manufactured in China

Designed by Suzanne M. LaGasa

10 9 8 7 6 5 4 3 2 1

Chronicle Books LLC
680 Second Street
San Francisco, California 94107
www.chroniclebooks.com

Chronicle Books publishes distinctive books and gifts. From award-winning children's titles, best-selling cookbooks, and eclectic pop culture to acclaimed works of art and design, stationery, and journals, we craft publishing that's instantly recognizable for its spirit and creativity. Enjoy our publishing and become part of our community at www.chroniclebooks.com.

Table of Contents

· **INTRODUCTION, 7** ·

a real friend will help you hide the body
· **FRIENDSHIP, 8** ·

she threw herself eagerly into the paths of unsuitable men
· **DATING, 22** ·

love . . . honor . . . and *what?!?*
· **WEDDED BLISS, 36** ·

WOW! I get to give birth AND change diapers!
· **MOTHERHOOD, 50** ·

another day in paradise . . .
· **THE DOMESTIC GODDESS, 64** ·

why yes, I am overqualified
· **AT THE OFFICE, 78** ·

screw the budget!
· **MONEY, 92** ·

why am I sober?
· **COCKTAILS, 106** ·

we all have our baggage
· **TRAVEL AND LEISURE, 120** ·

let a smirk be your umbrella
· **ATTITUDE, 134** ·

old enough to know better . . . too young to give a rat's ass
· **THE WOMAN OF EXPERIENCE, 148** ·

the holidays, she believed, were no time to exercise restraint
· **THE HOLIDAYS, 162** ·

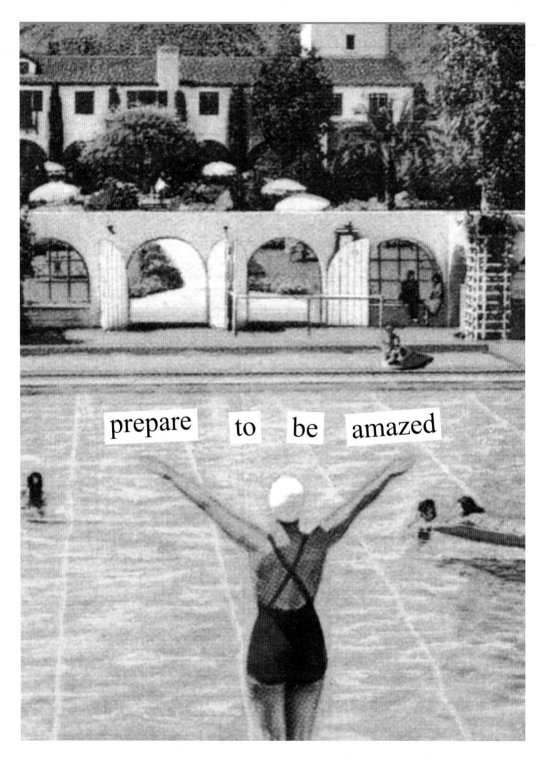

Introduction

I started out life as a bit of a scamp. By the middle of first grade, however, the Sisters of Mercy had put a firm lid on that. For the next eight years, I was so well-behaved that even the nuns thought I was a goody two-shoes. Eventually, I escaped to public school, and by the time I was a sophomore in high school and my sister Liz was a freshman, it was pretty difficult to discern who was setting a bad example for whom. Mothers wept. Fathers gnashed their teeth. Then along came our younger sister Ellen, and we all had to bow to the master.

Setting a bad example does not necessarily mean being bad. It might just mean doing what you want instead of what others expect from you. It might mean being a bit more adventurous than the average bear. Or it might mean saying, as do the women on these pages, just exactly what's on your mind. This book is for Liz, for Ellen, and for all women who choose their own paths and speak their own truths.

Friendship

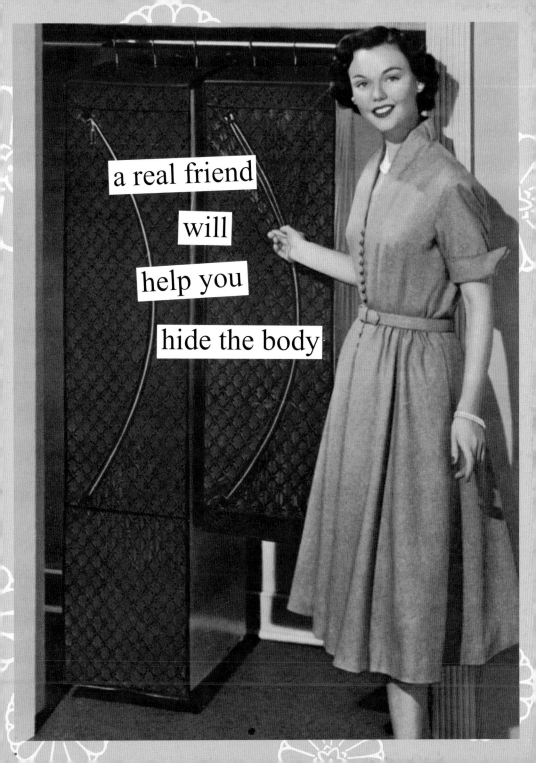

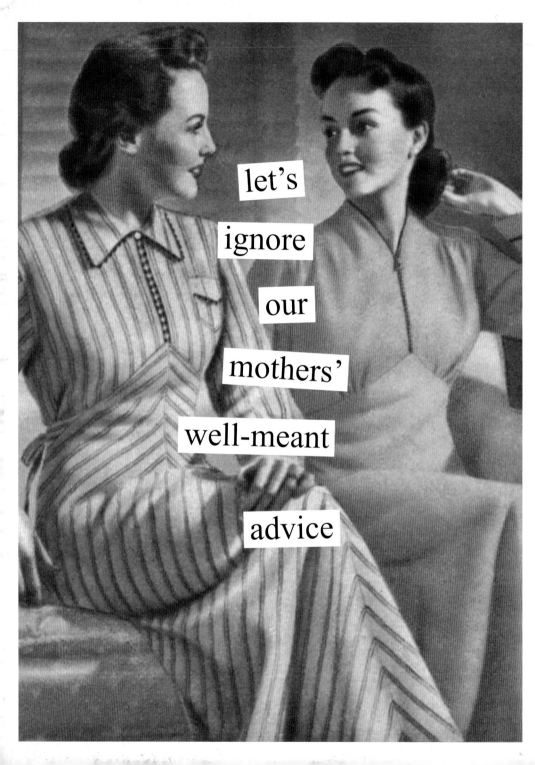

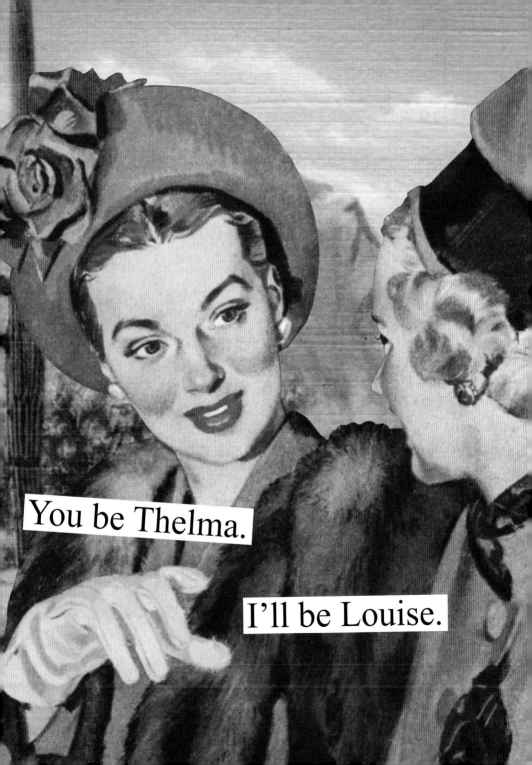

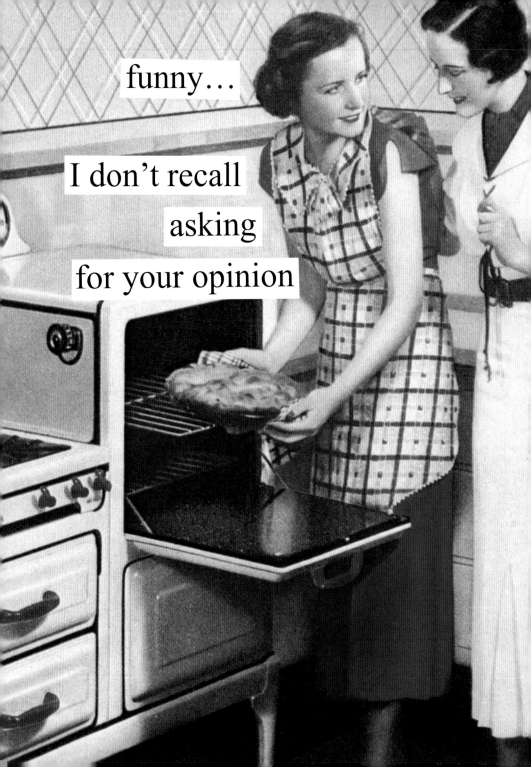

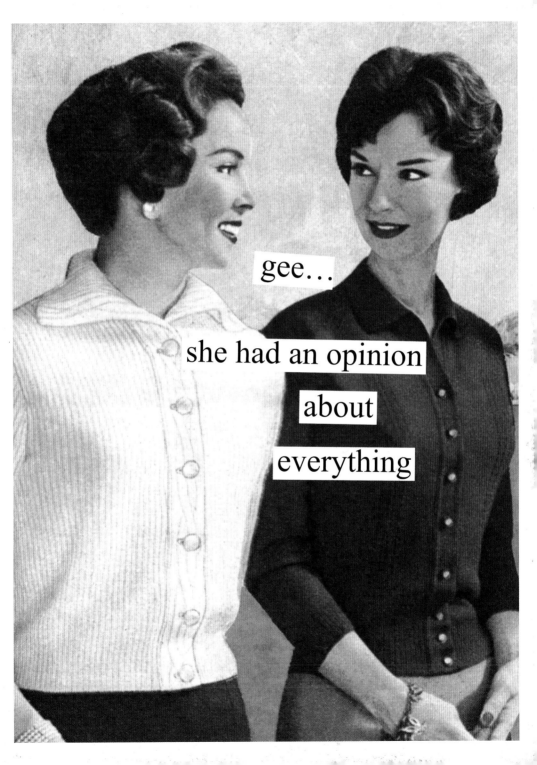

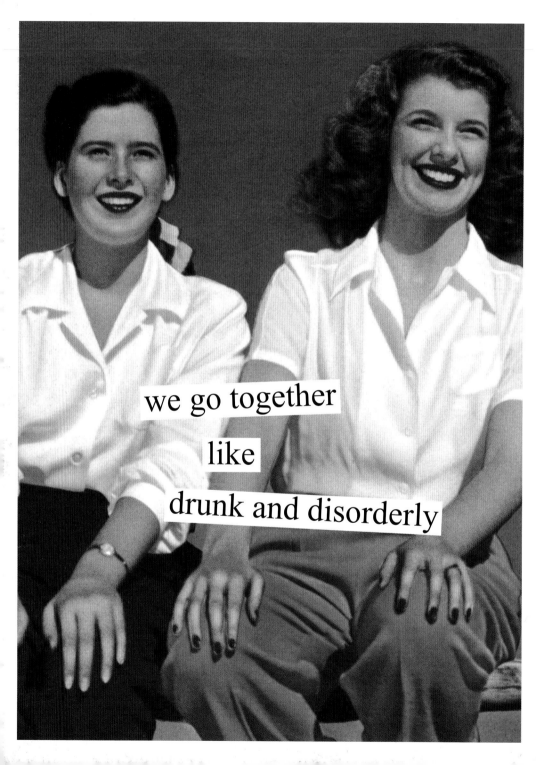

we go together

like

drunk and disorderly

born to be wild

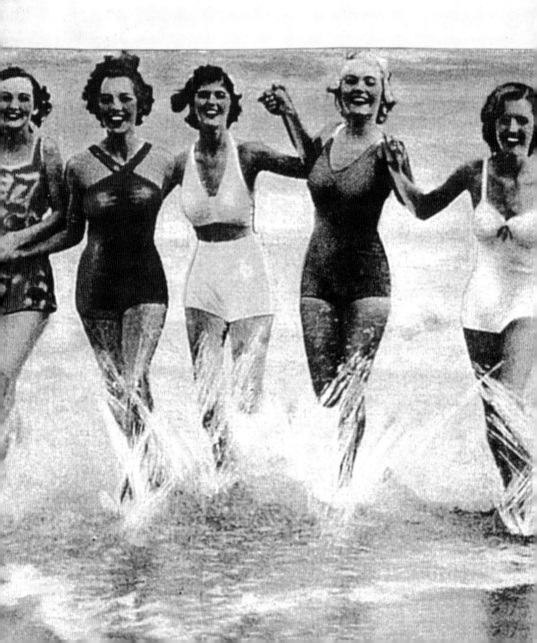

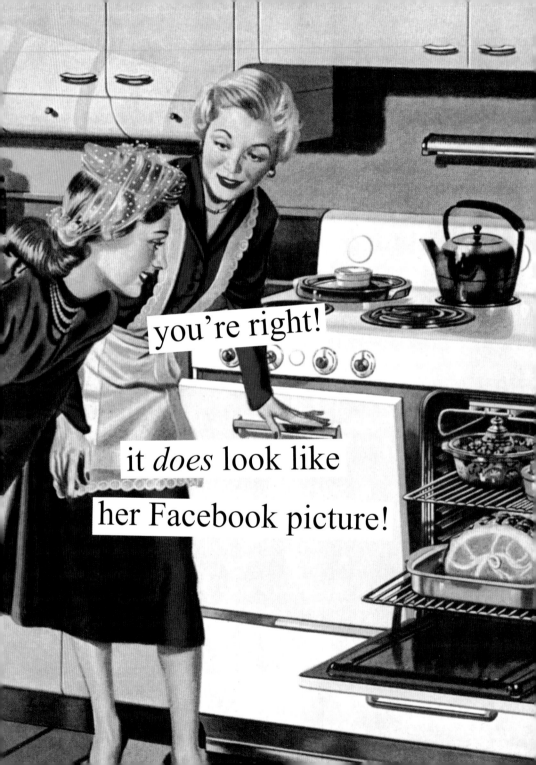

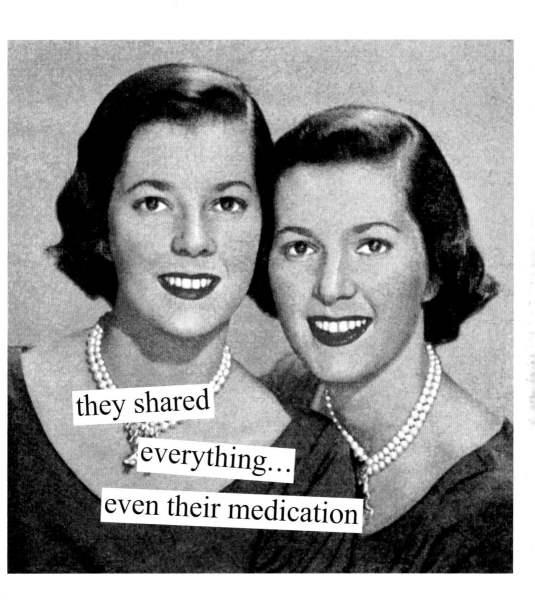

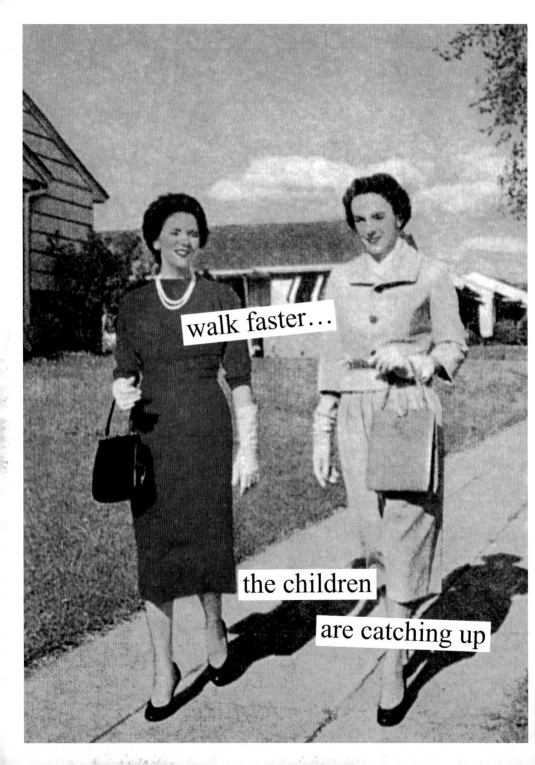

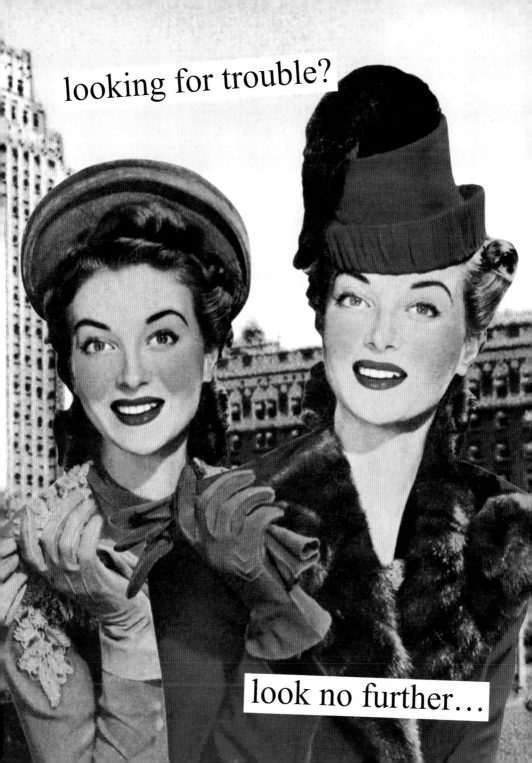

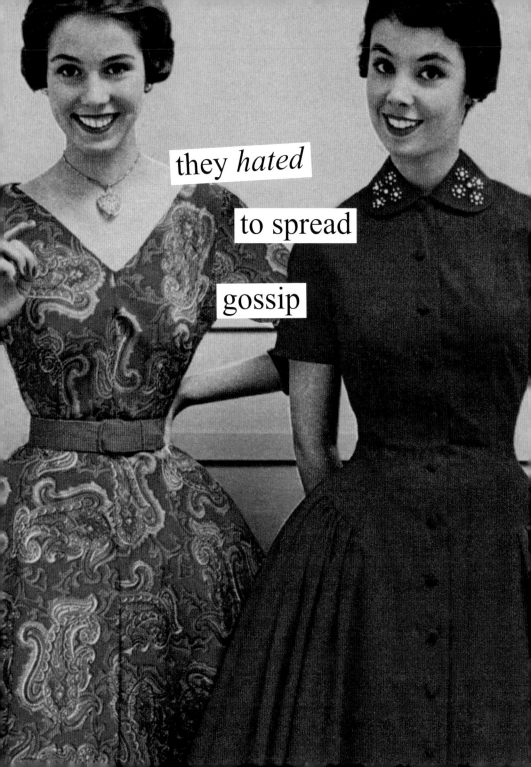

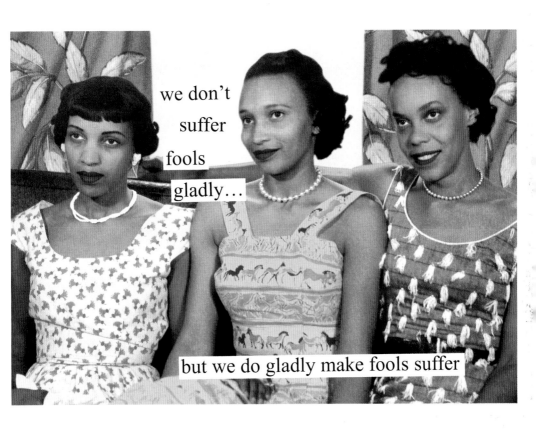

Dating

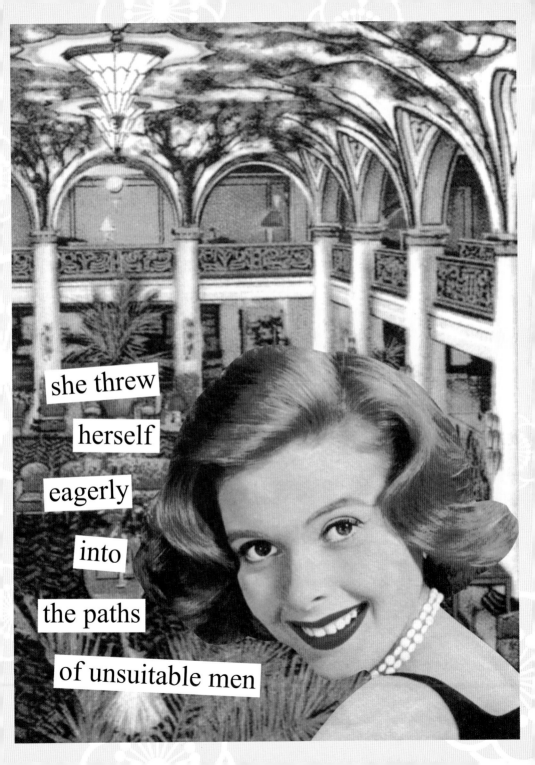

she threw
herself
eagerly
into
the paths
of unsuitable men

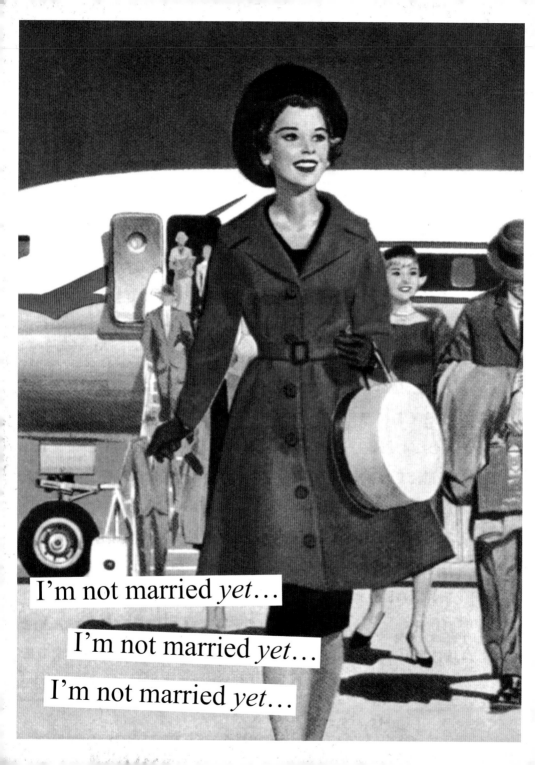

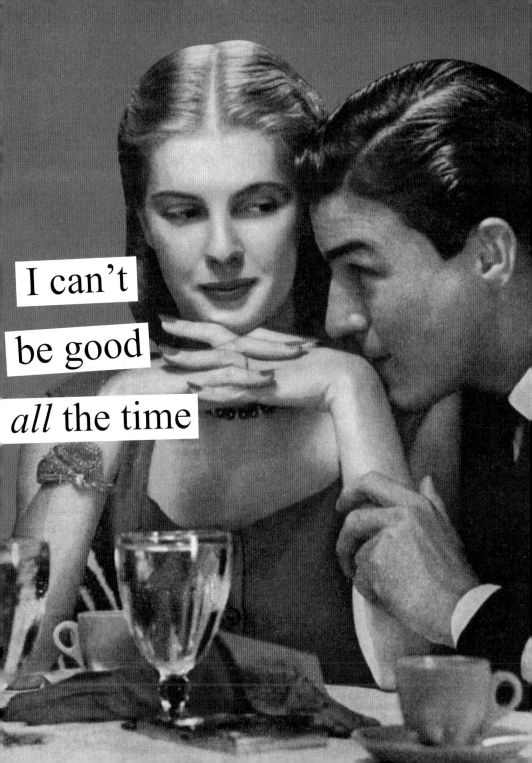

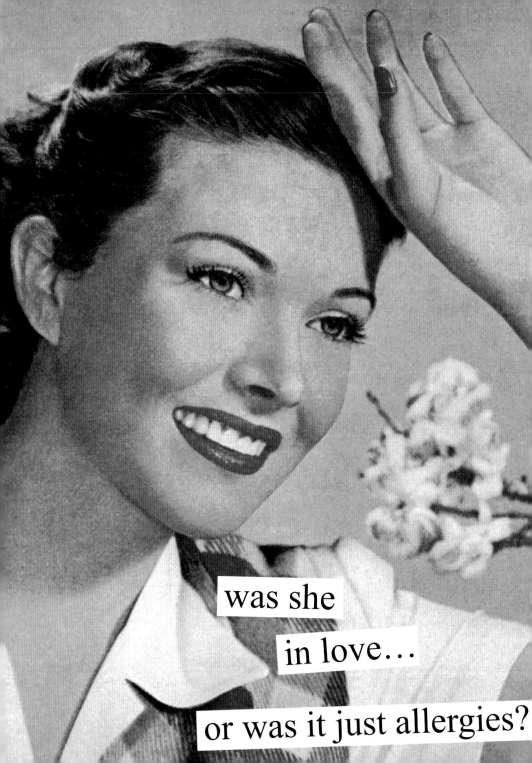

was she
in love…
or was it just allergies?

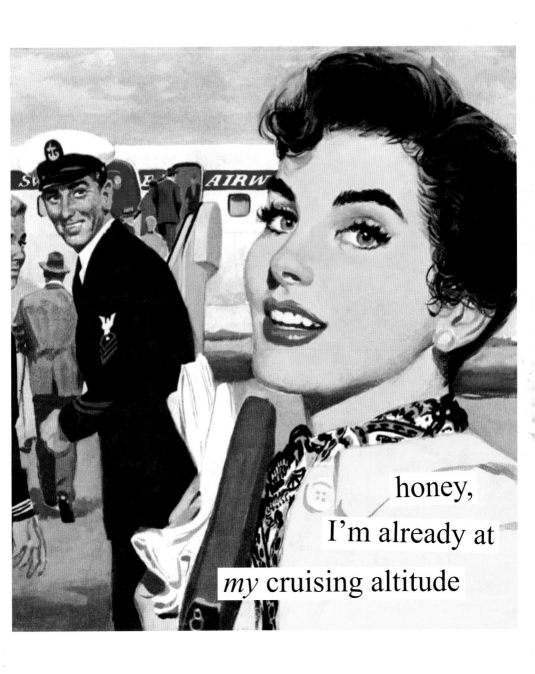

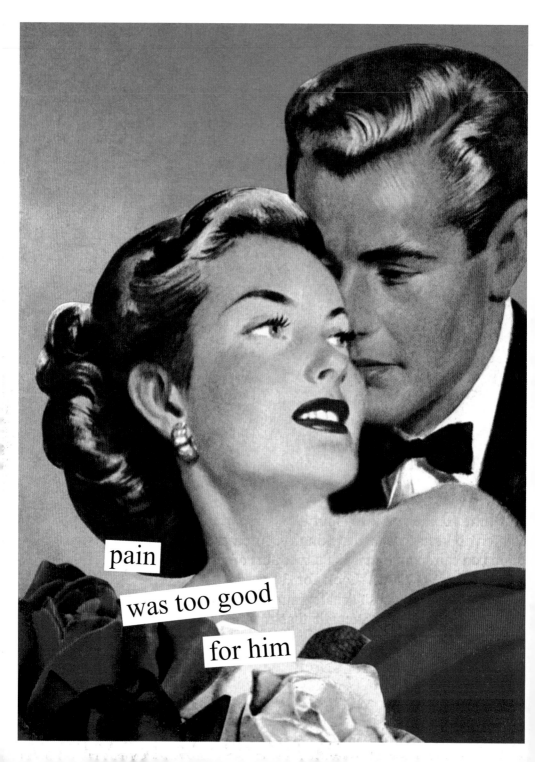

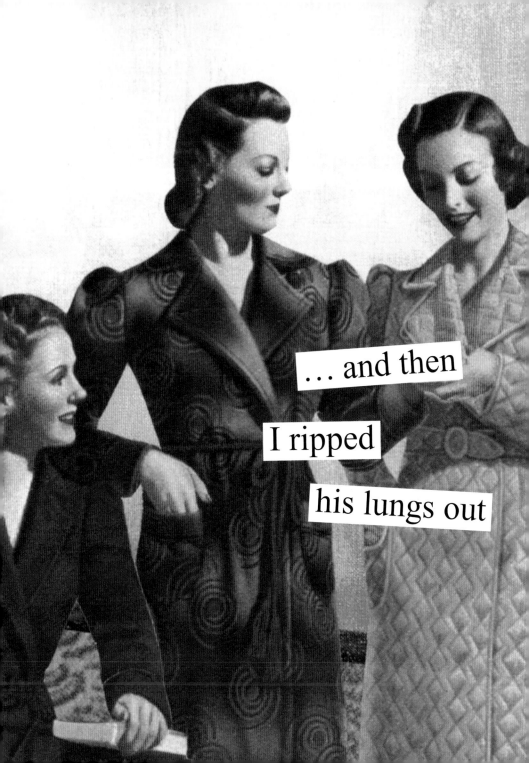

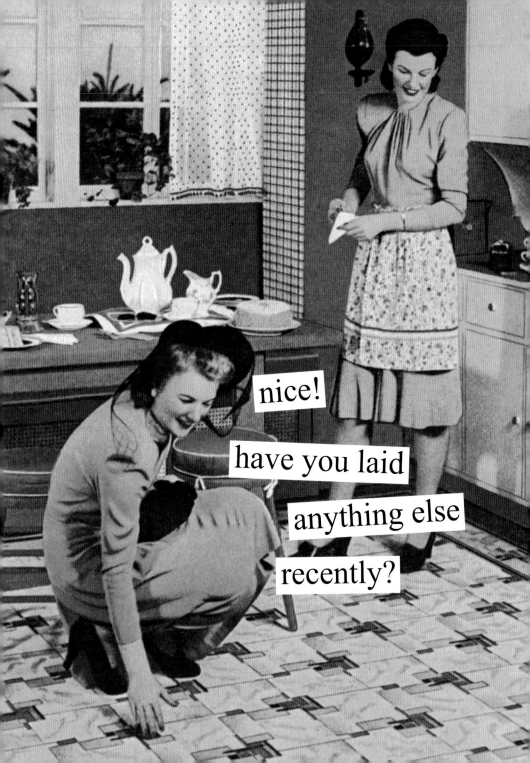

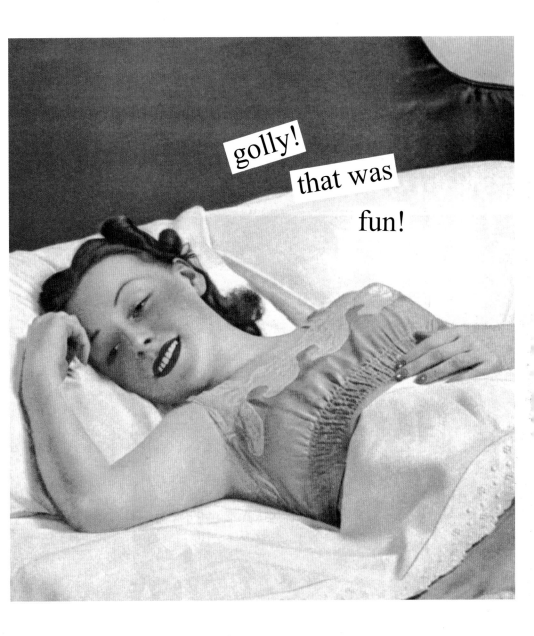

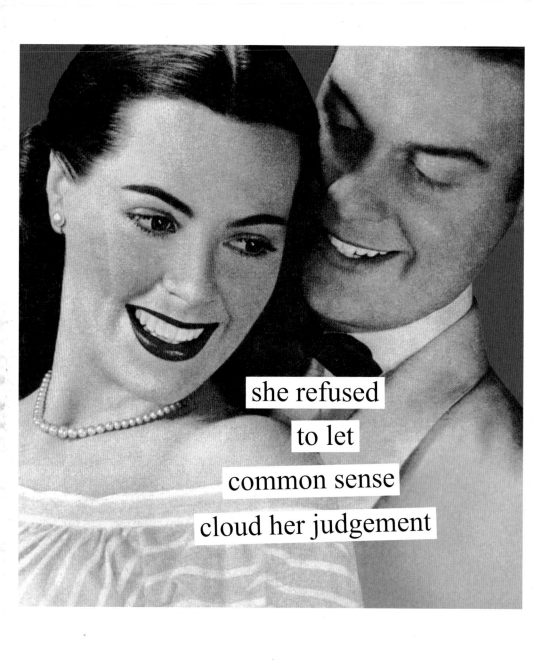

she refused
to let
common sense
cloud her judgement

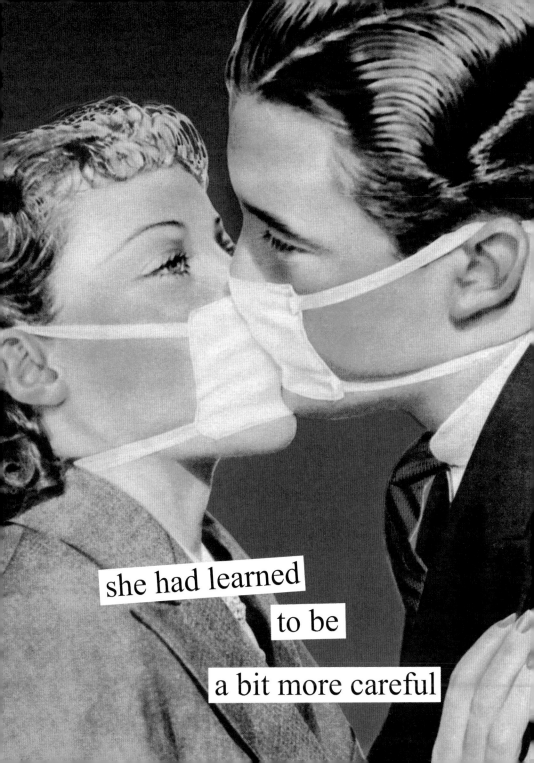

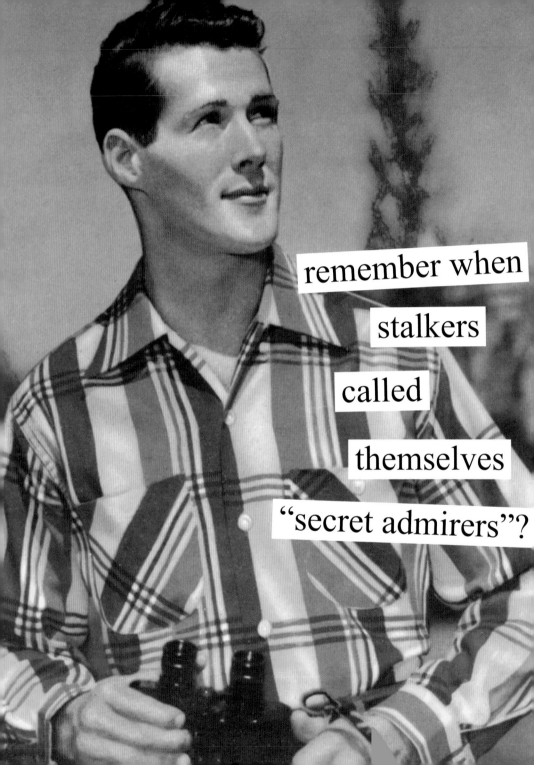

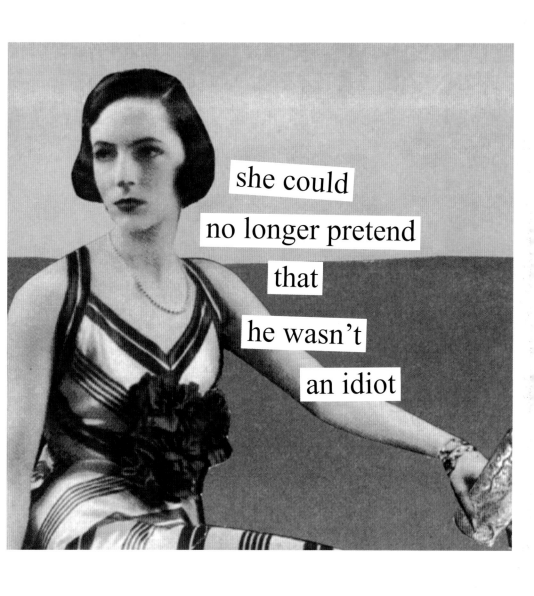

Wedded

Bliss

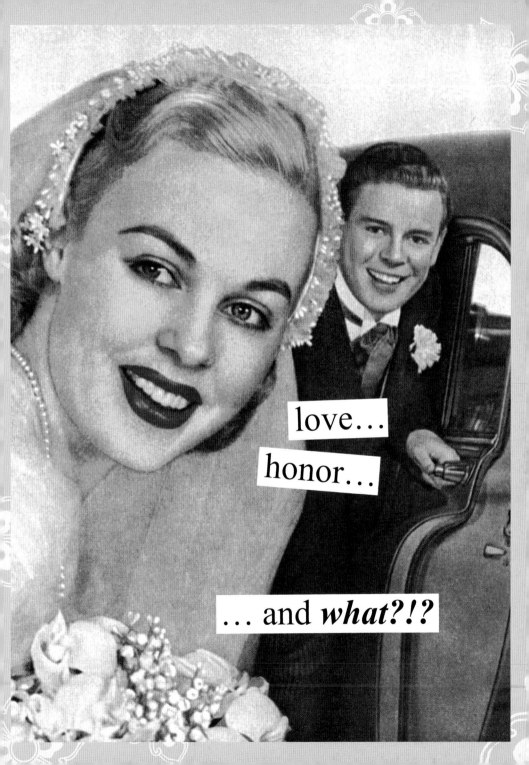

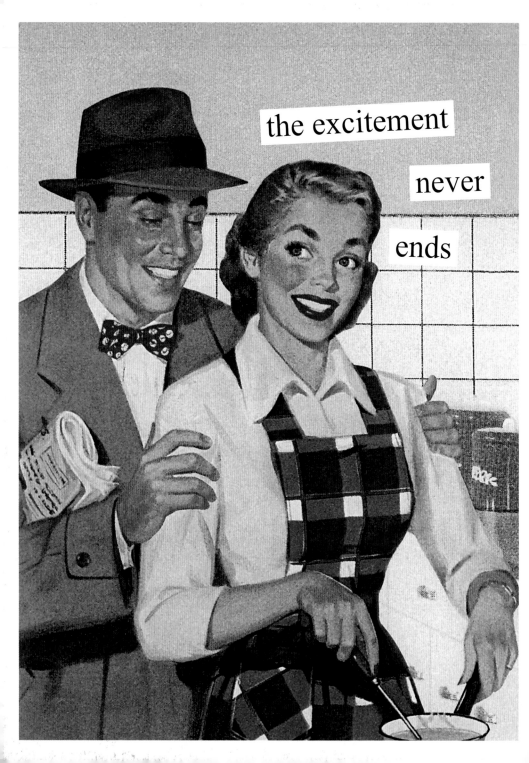

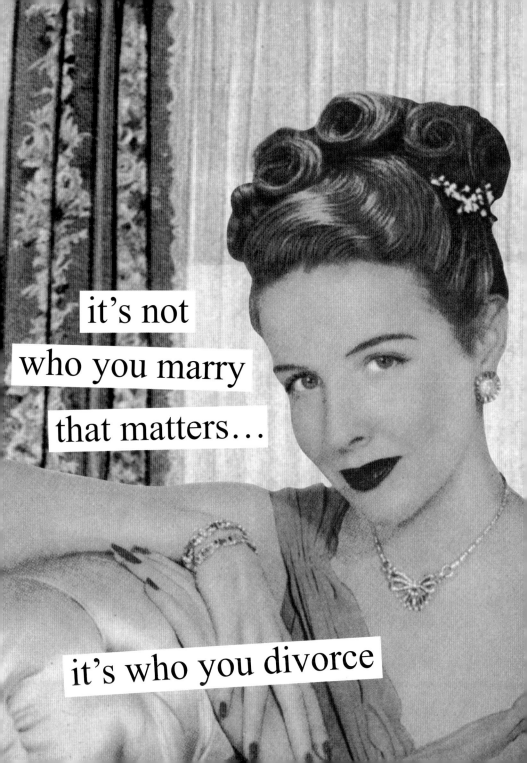

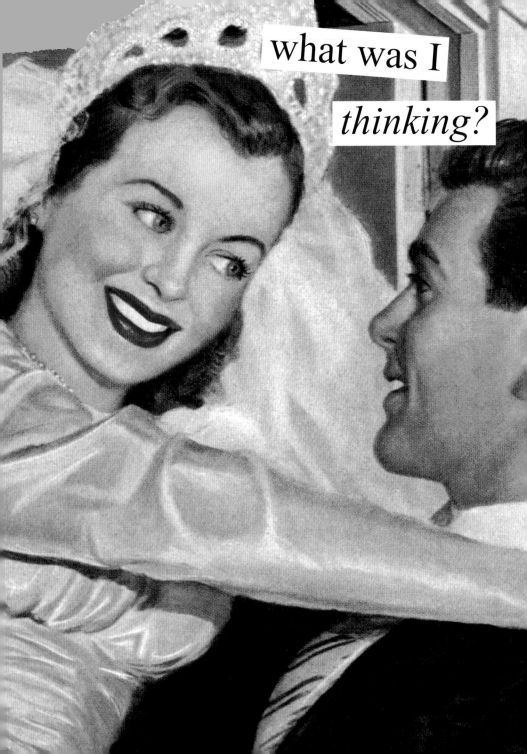

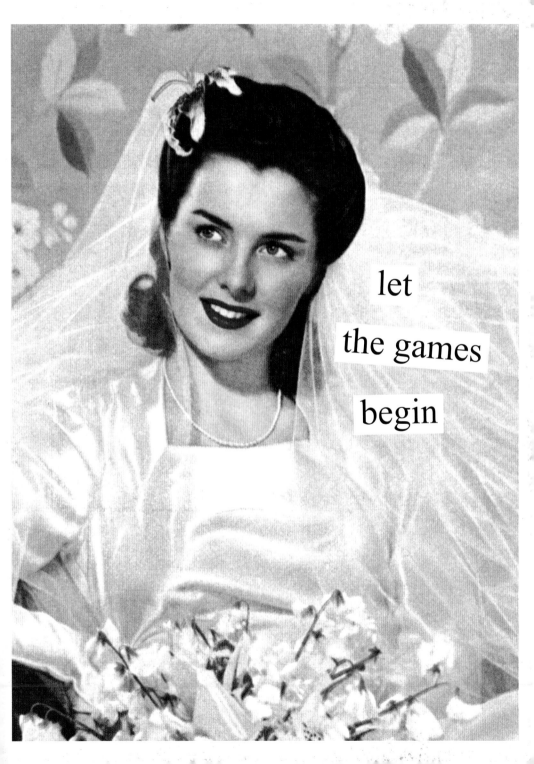

let
the games
begin

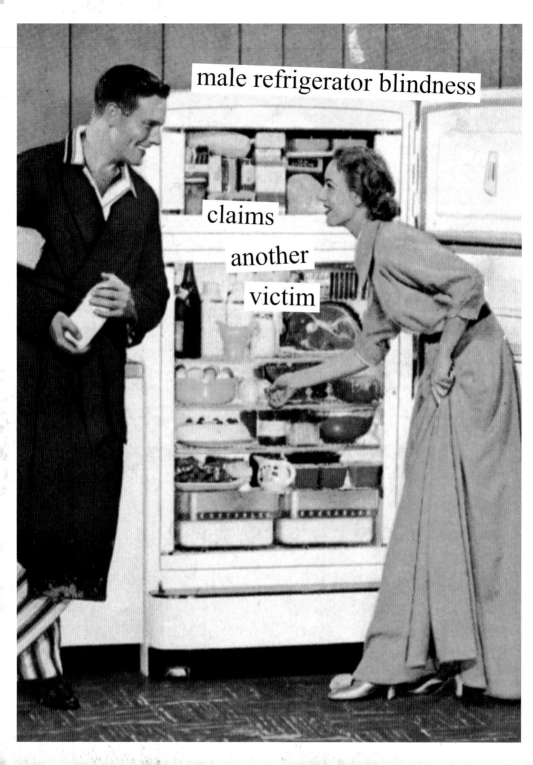

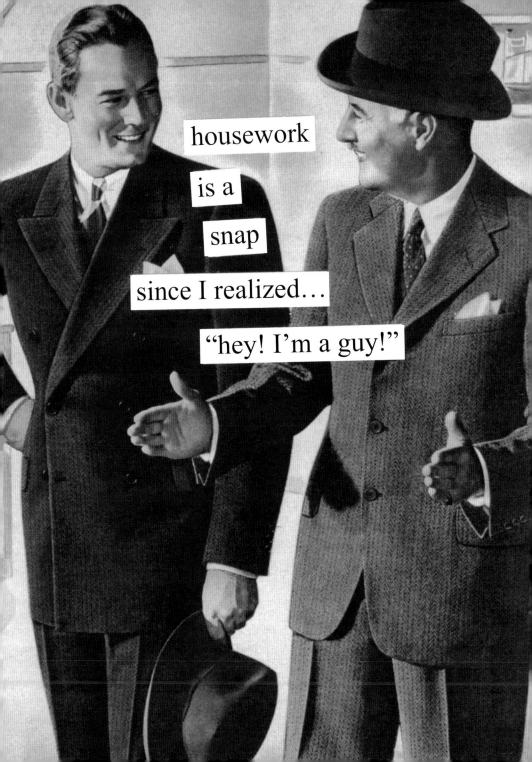

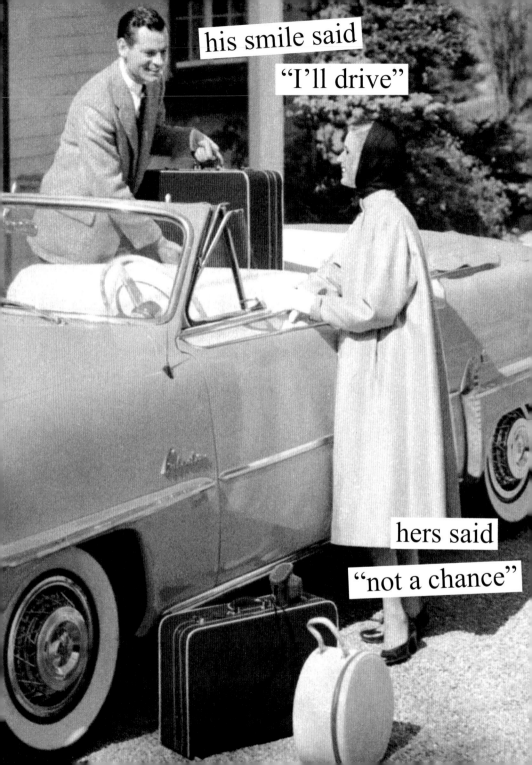

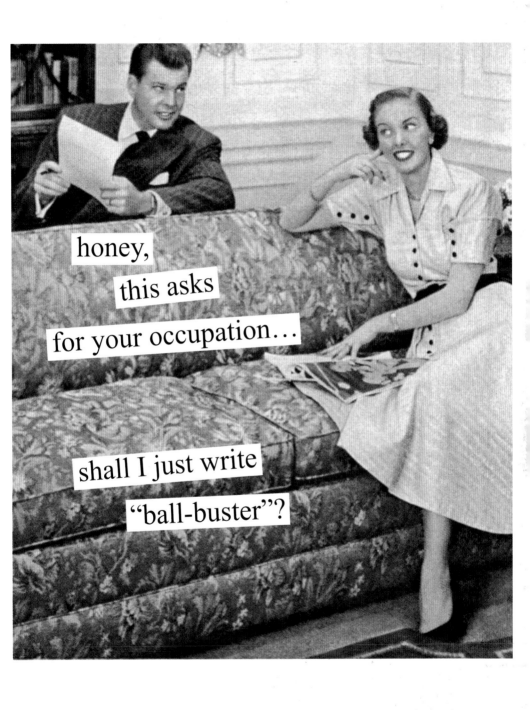

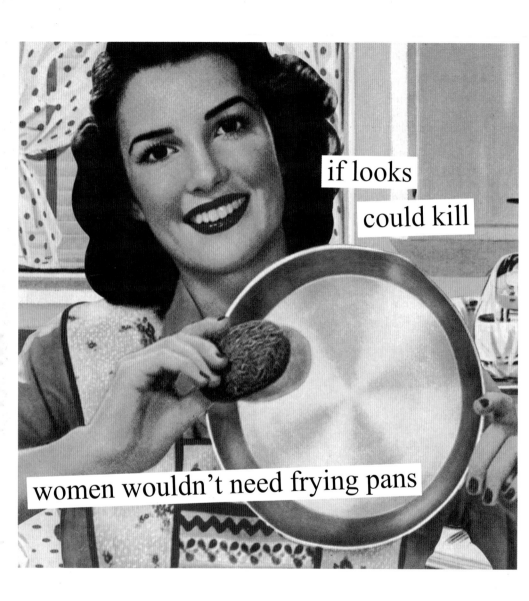

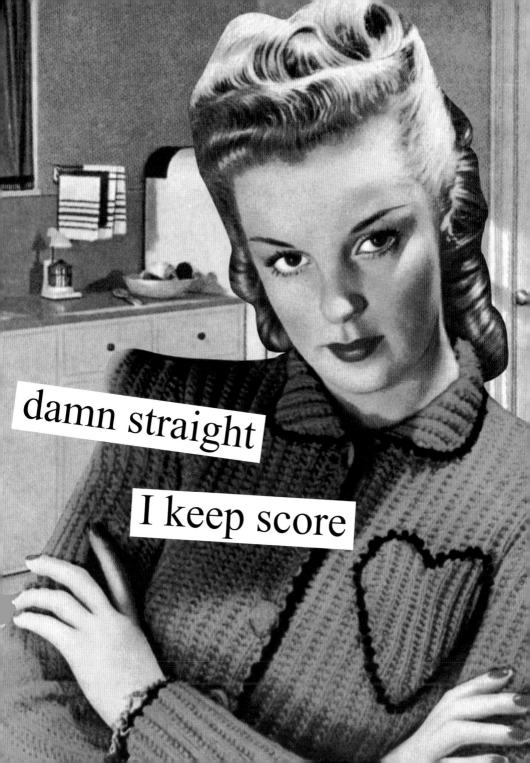

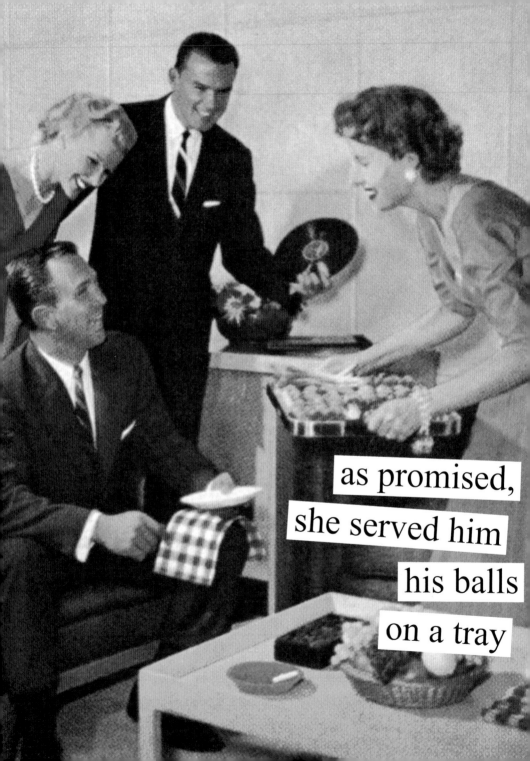

as promised,
she served him
his balls
on a tray

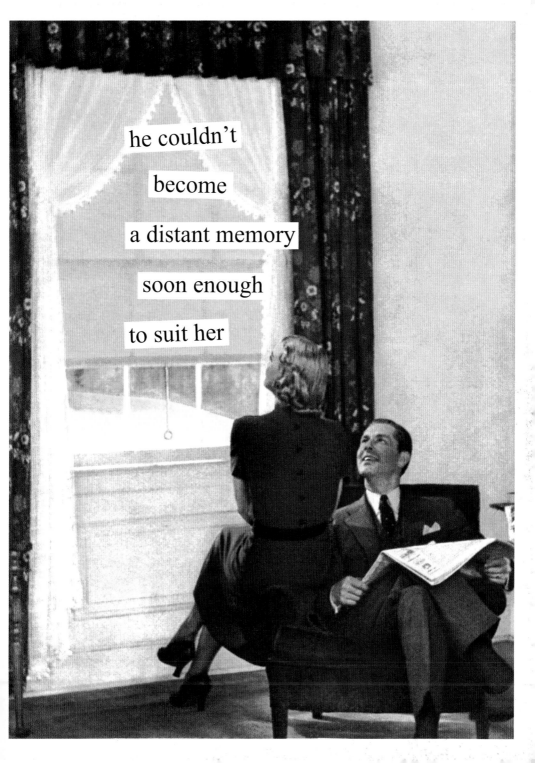

he couldn't

become

a distant memory

soon enough

to suit her

Motherhood

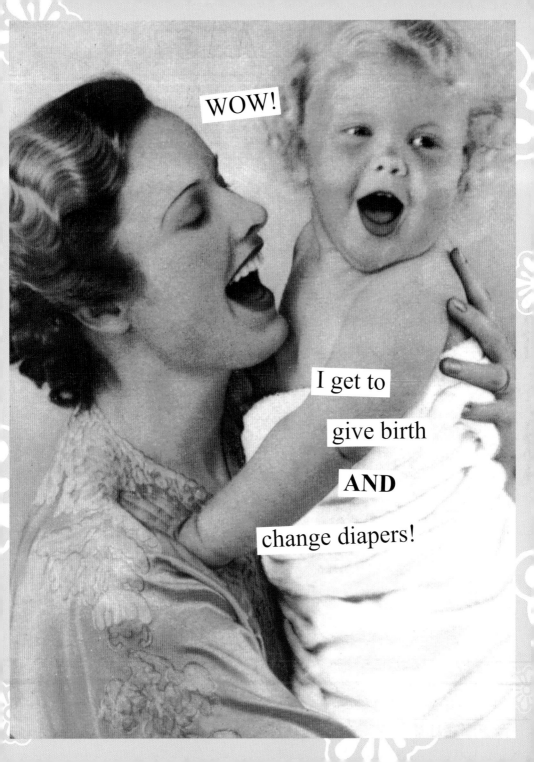

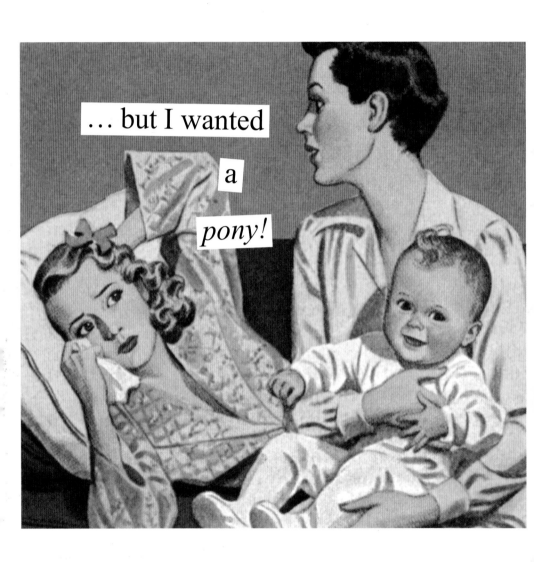

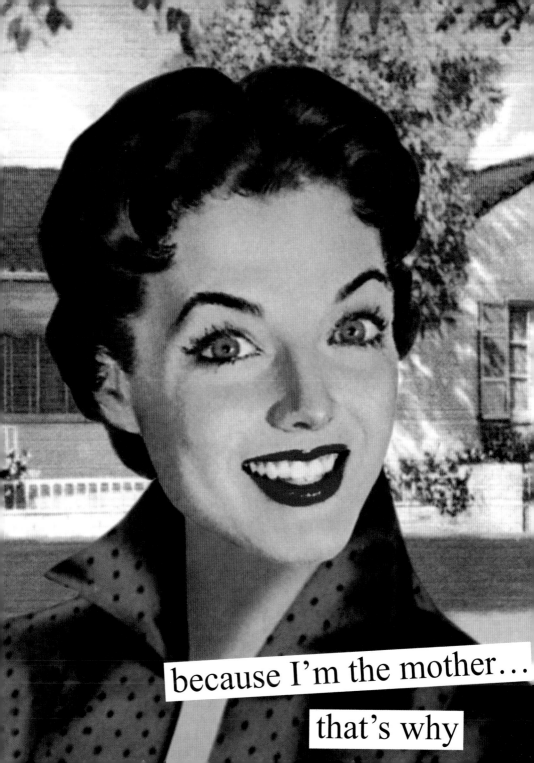

because I'm the mother...
that's why

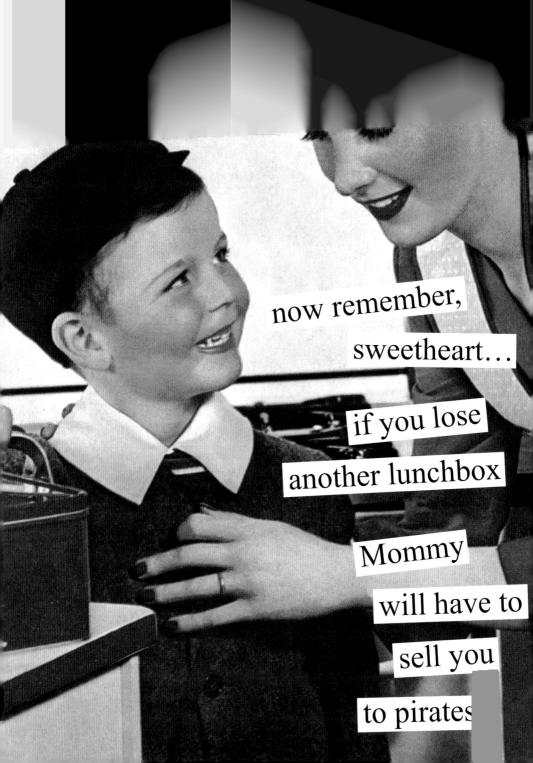

now remember, sweetheart… if you lose another lunchbox Mommy will have to sell you to pirates

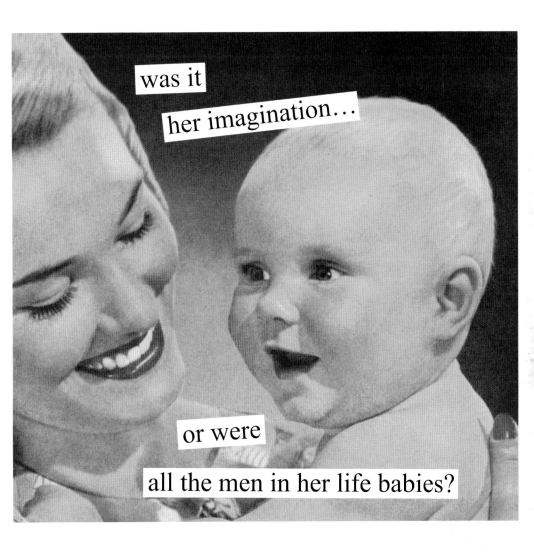

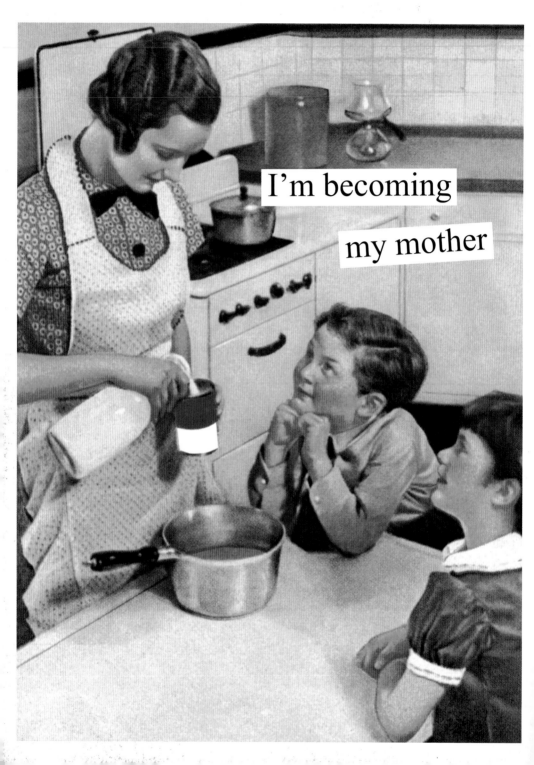

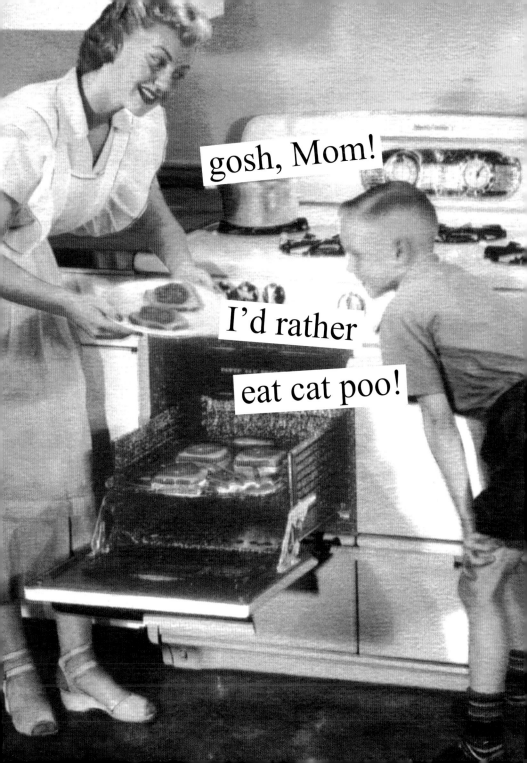

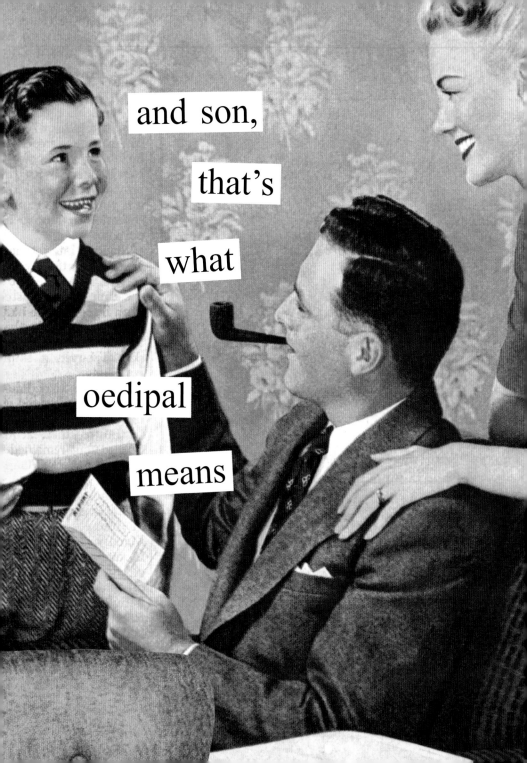

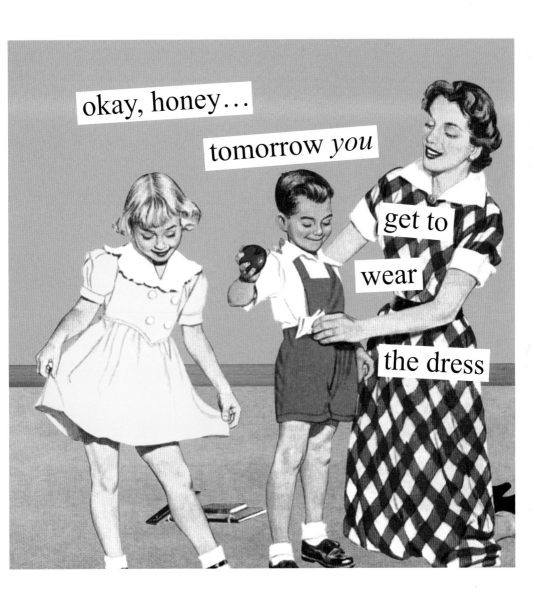

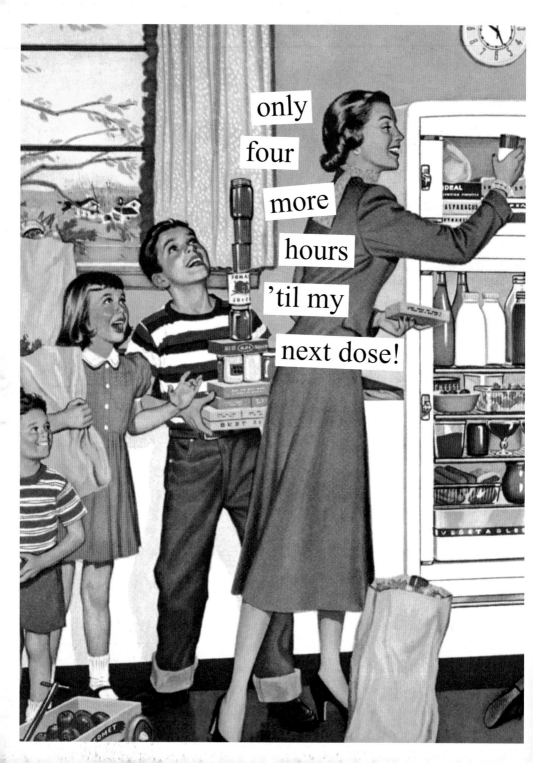

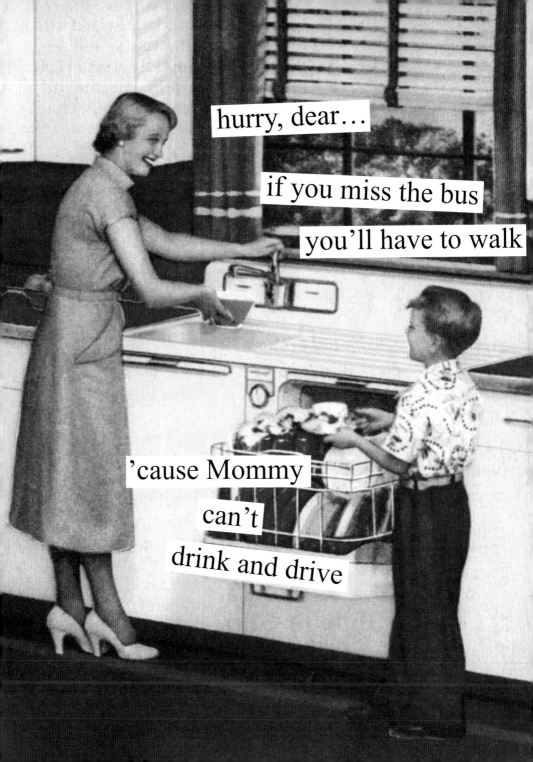

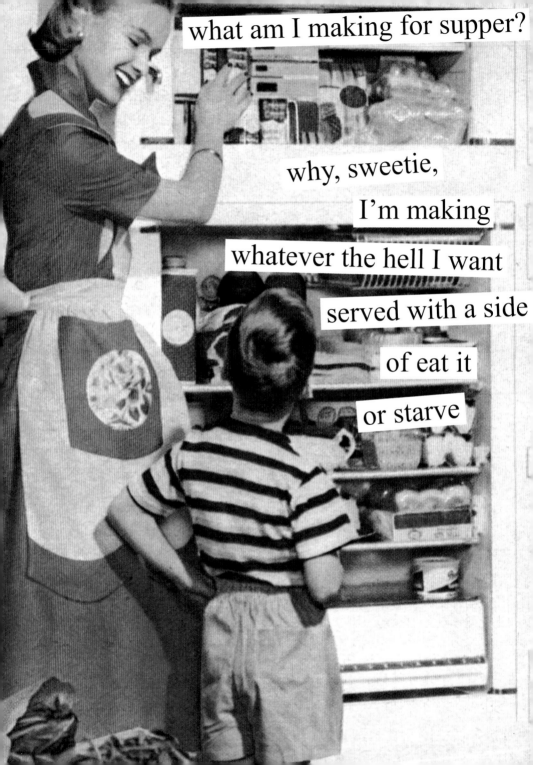

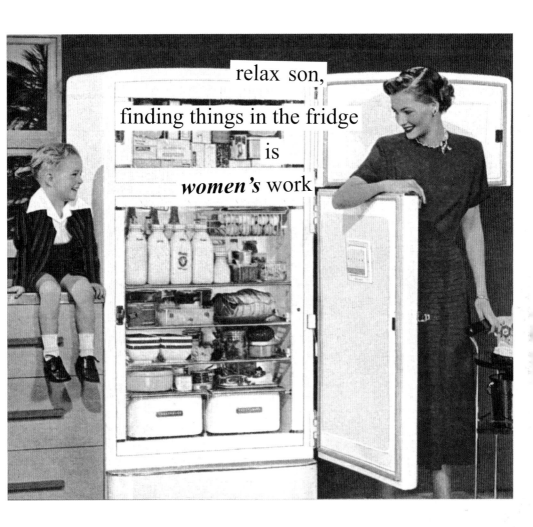

relax son,
finding things in the fridge is
women's work

The Domestic
Goddess

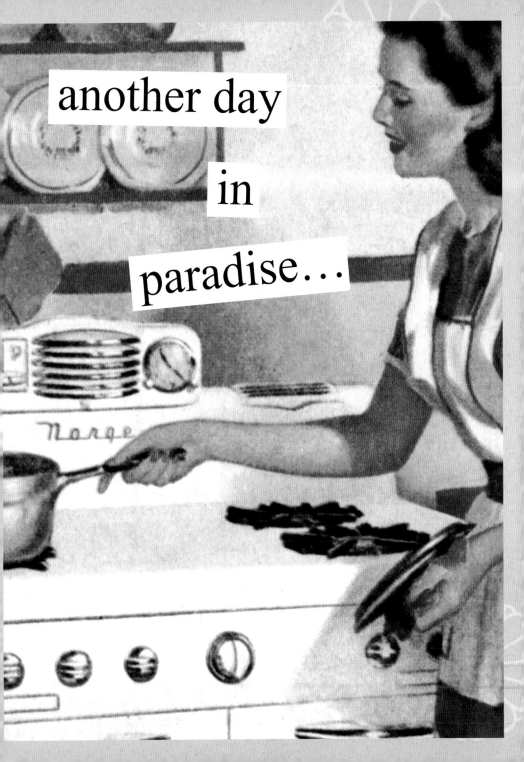

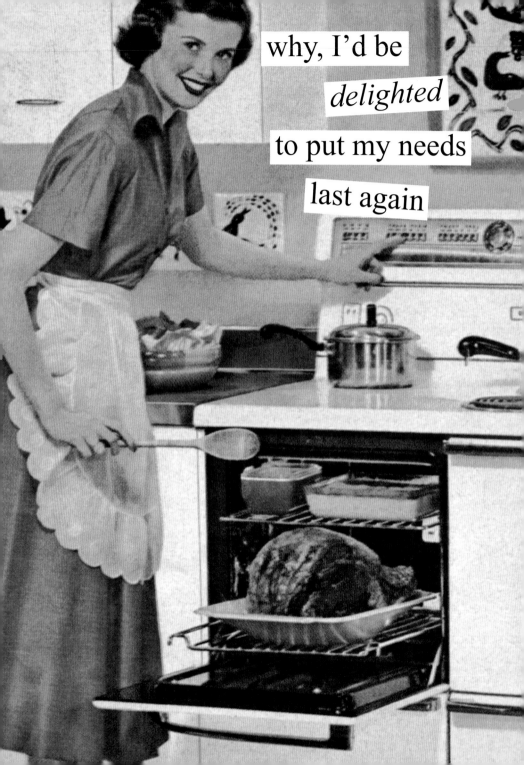

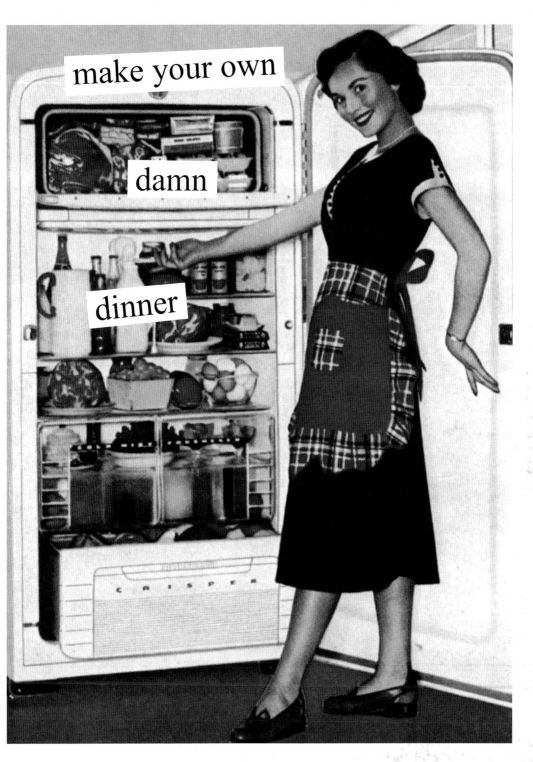

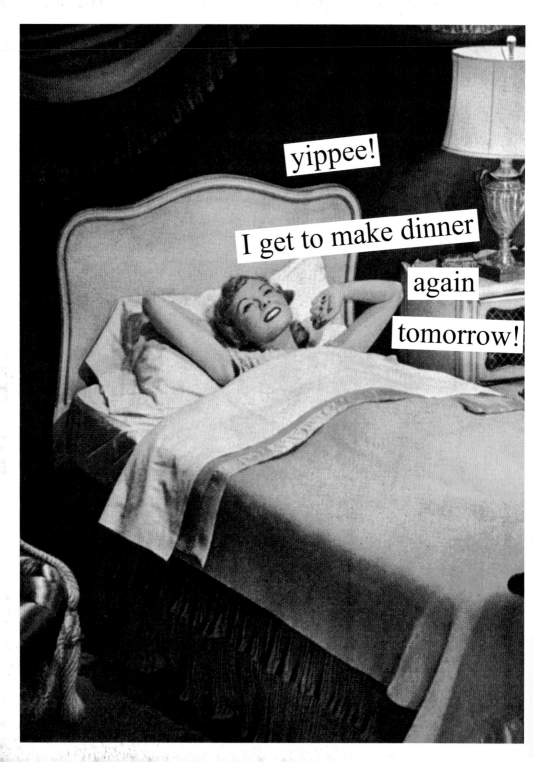

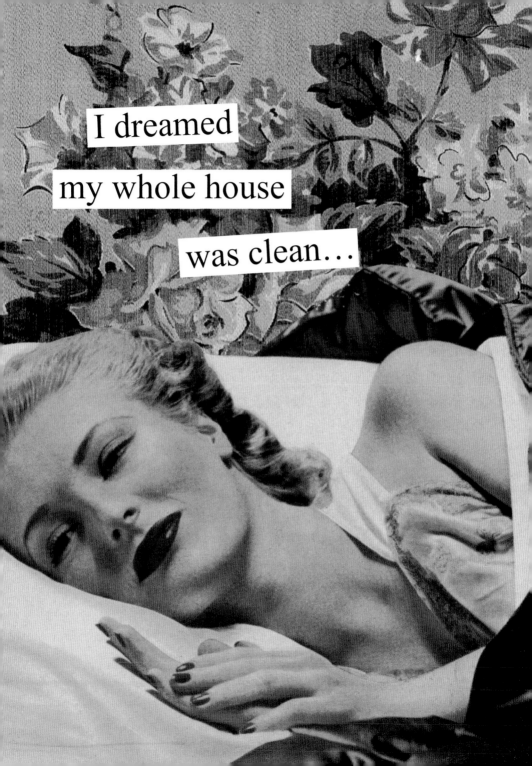

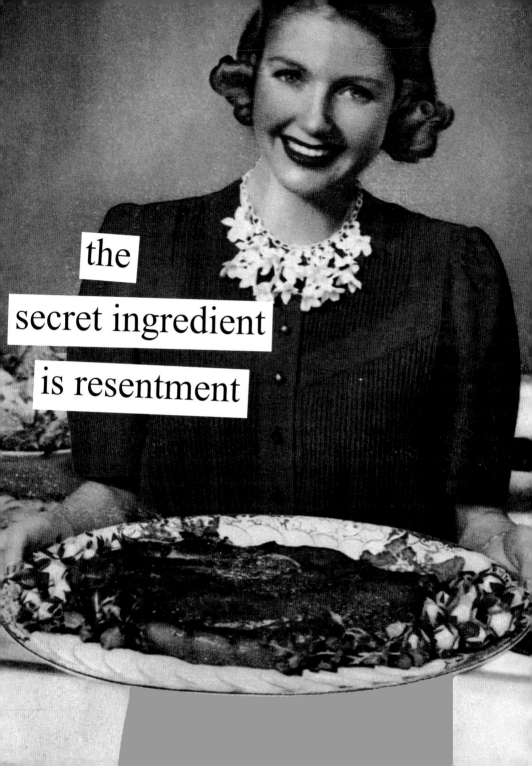

you'll eat it...

you'll eat it and *like* it

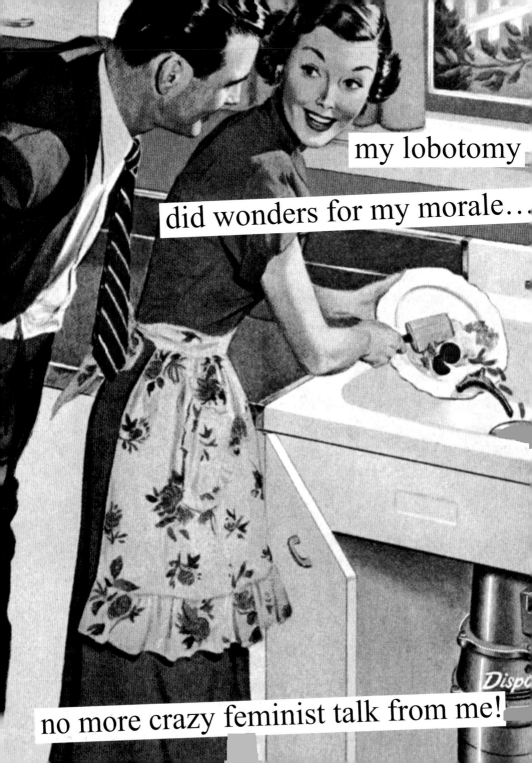

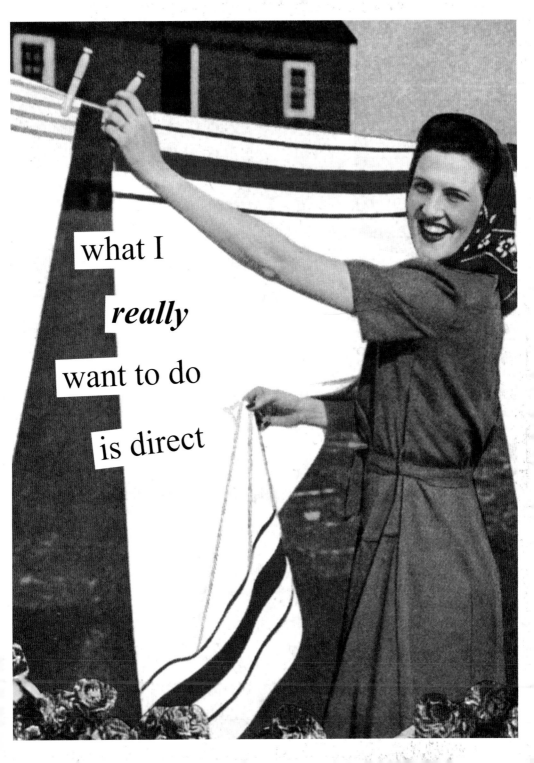

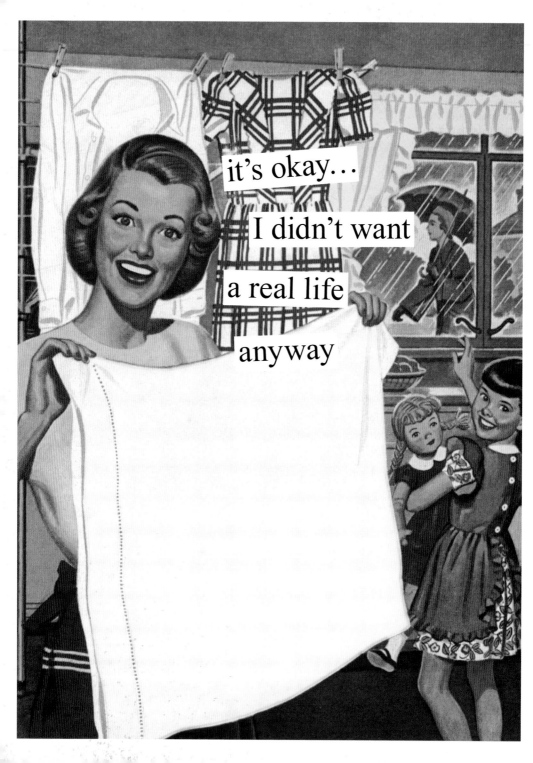

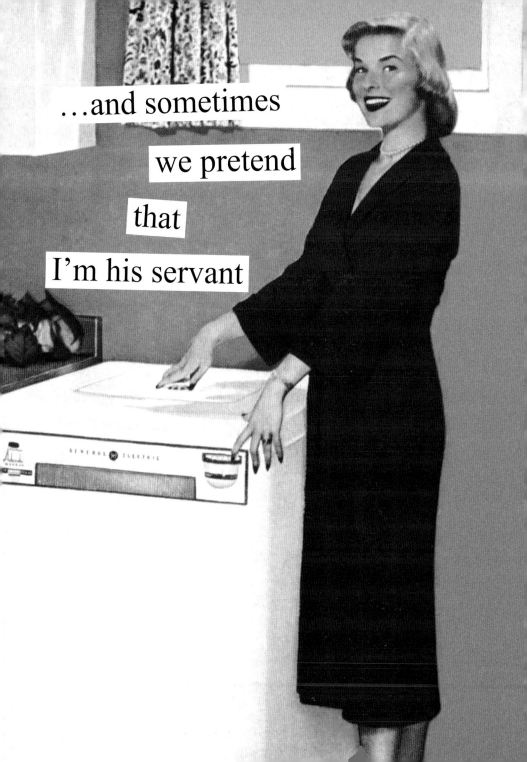

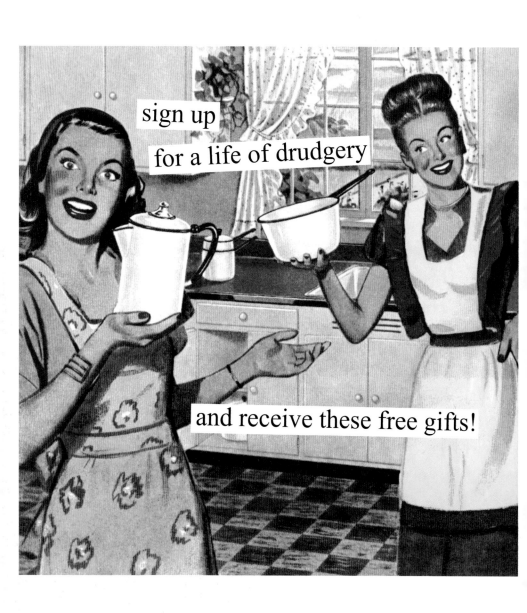

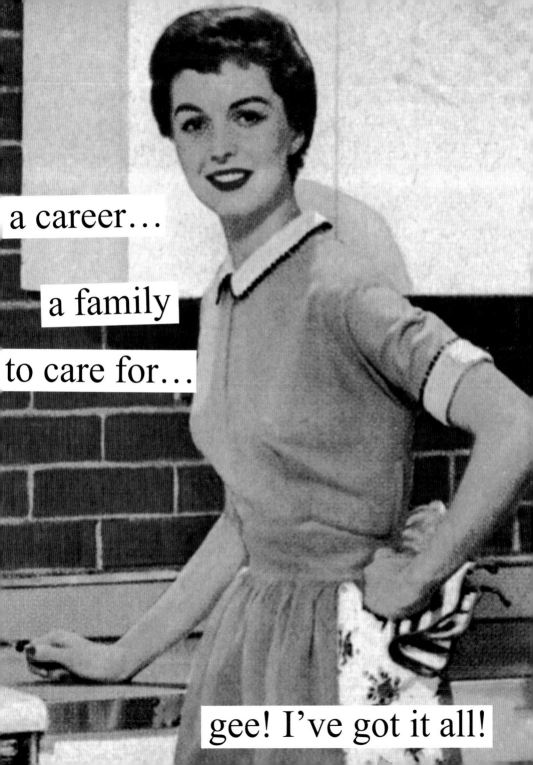

At the Office

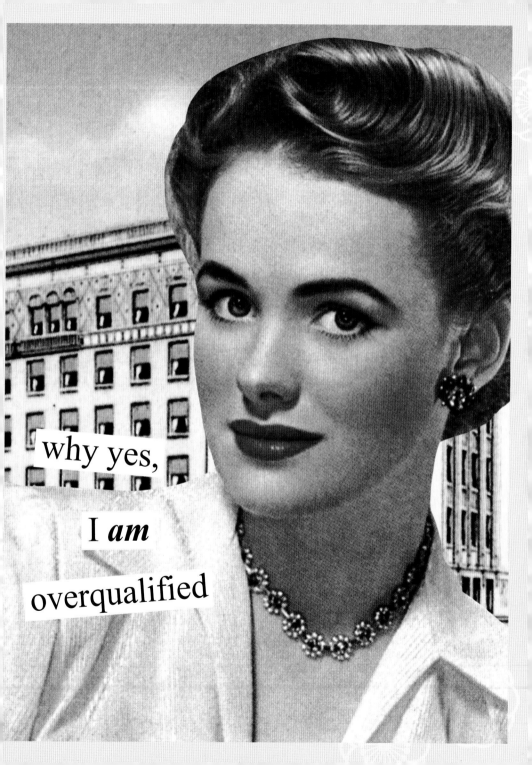

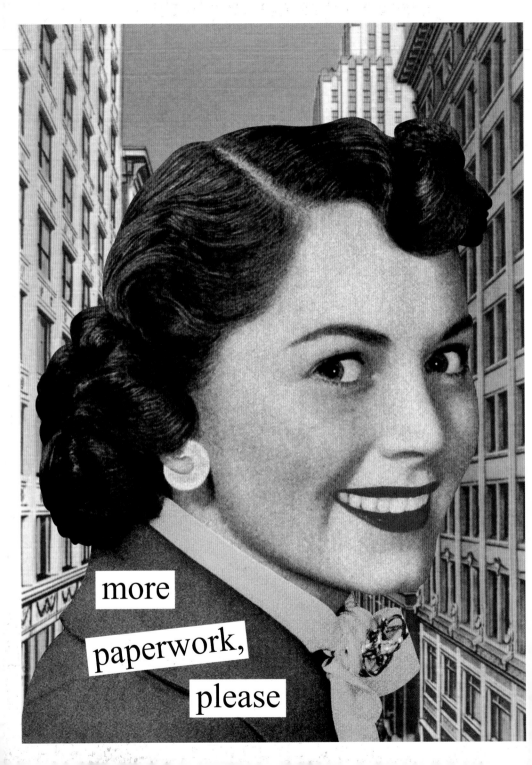

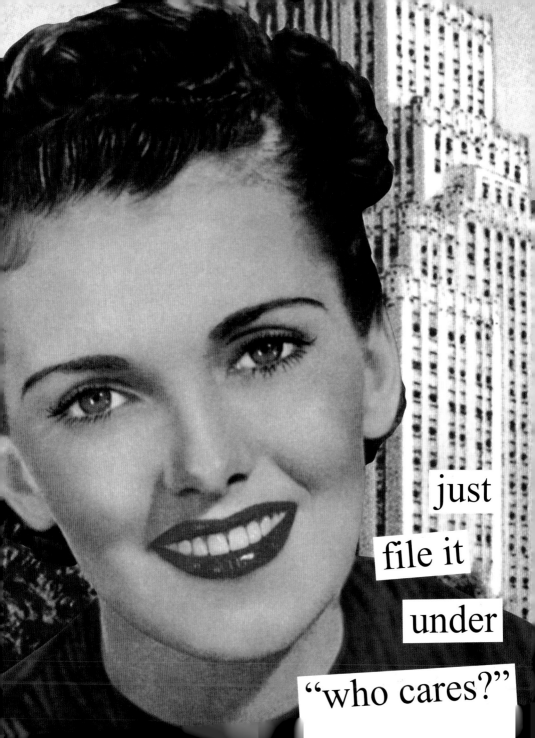

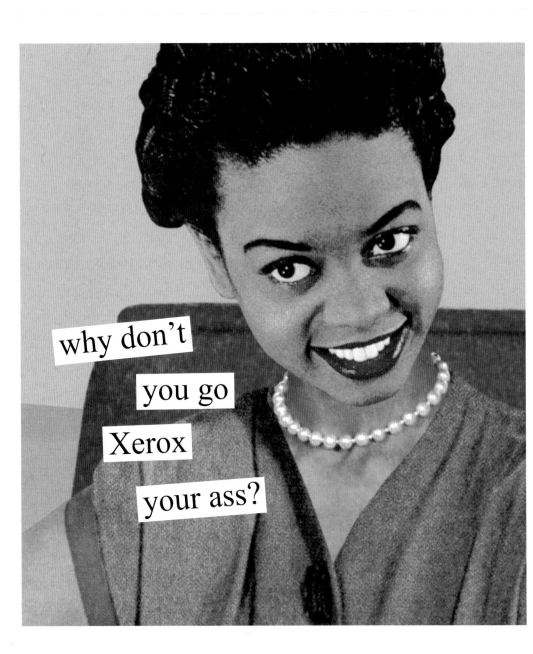

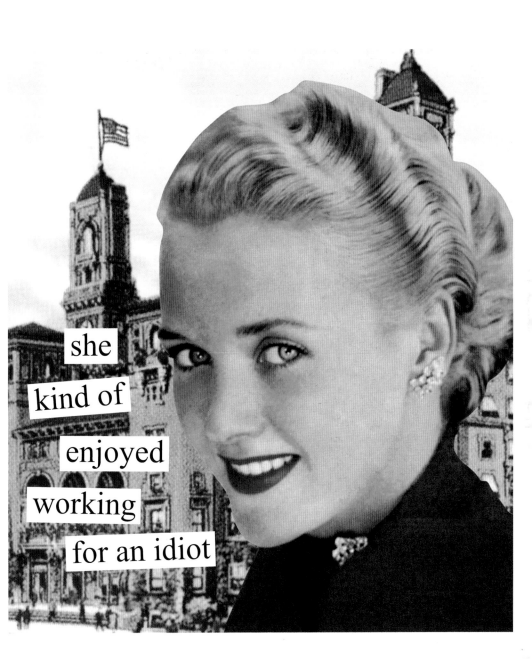

she
kind of
enjoyed
working
for an idiot

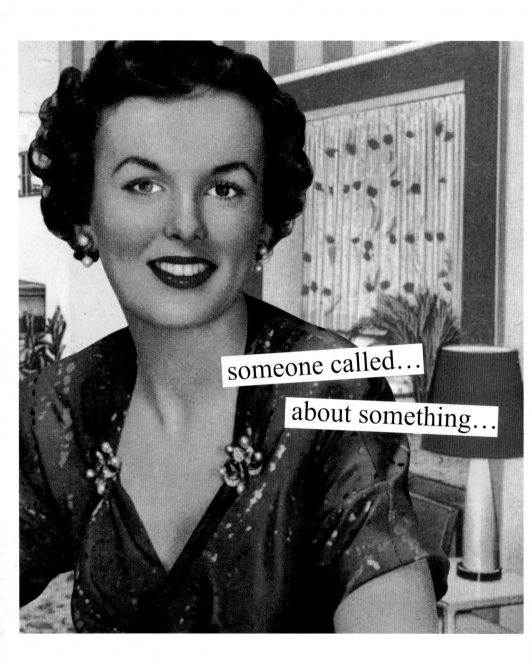

someone called...

about something...

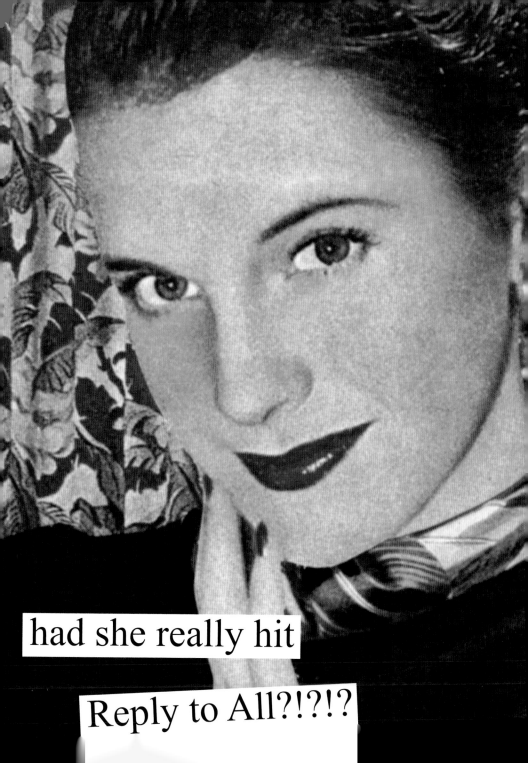

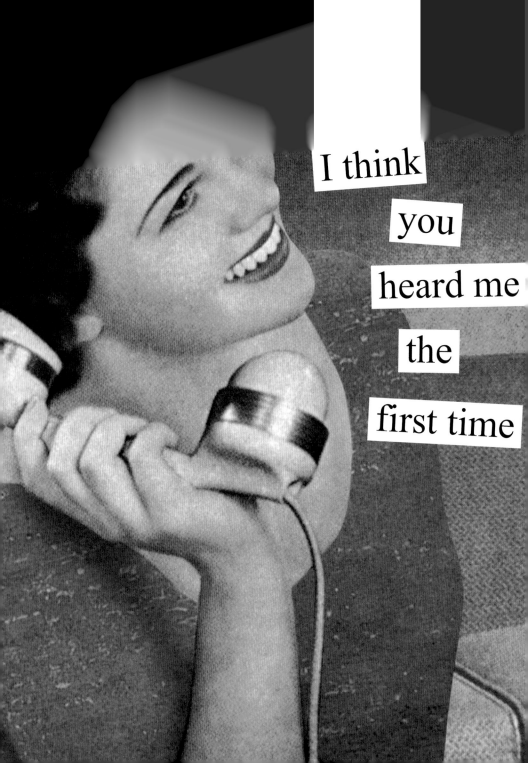

I think you heard me the first time

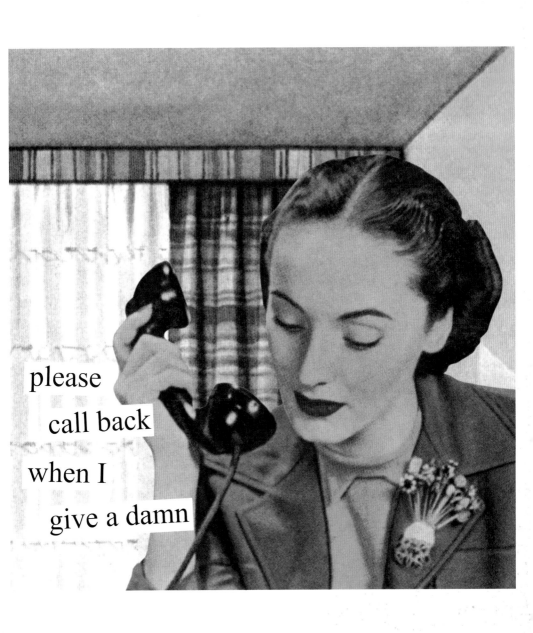

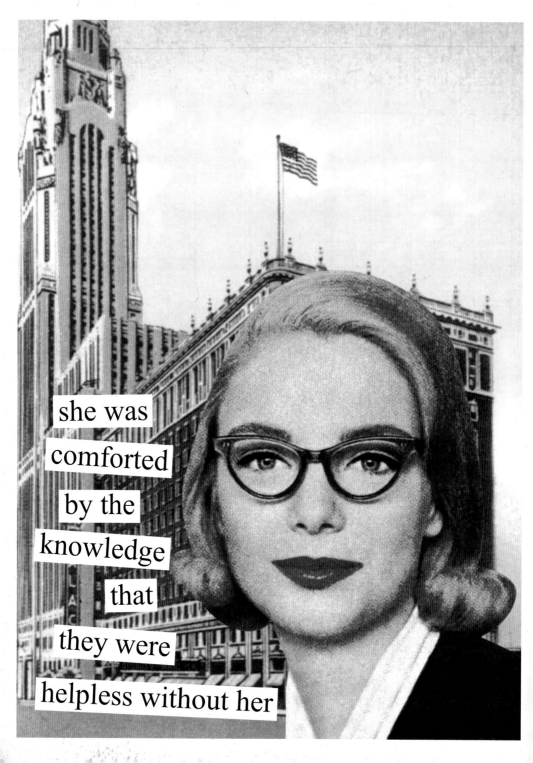

she was comforted by the knowledge that they were helpless without her

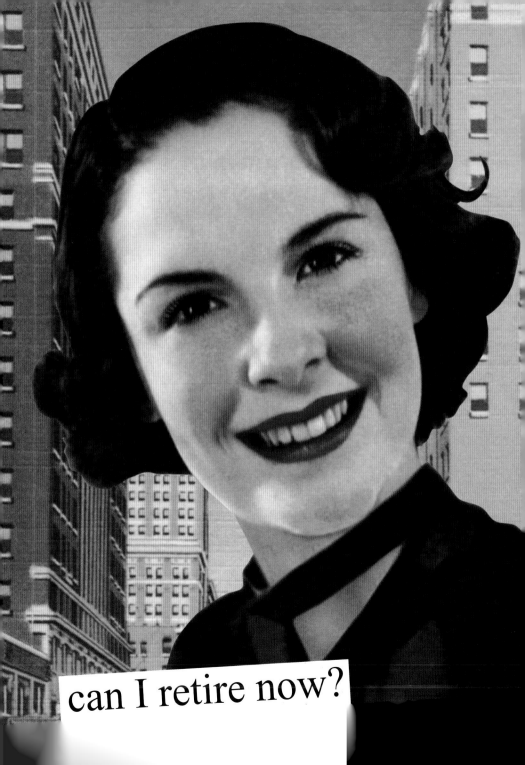

can I retire now?

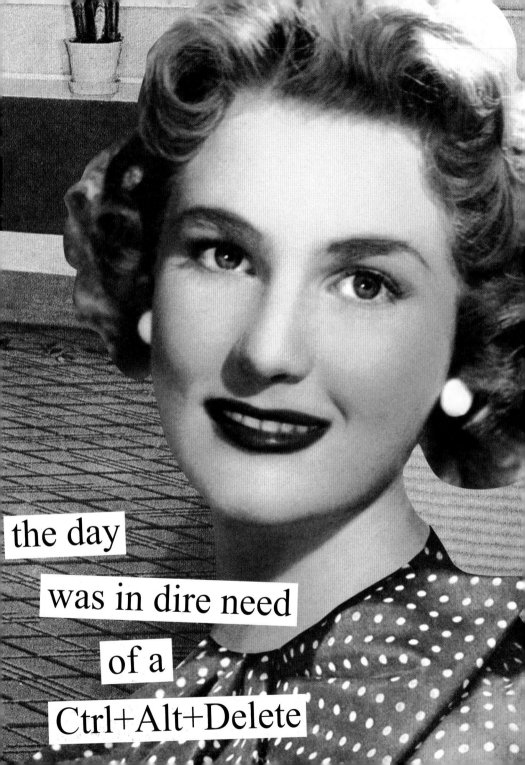

the day

was in dire need

of a

Ctrl+Alt+Delete

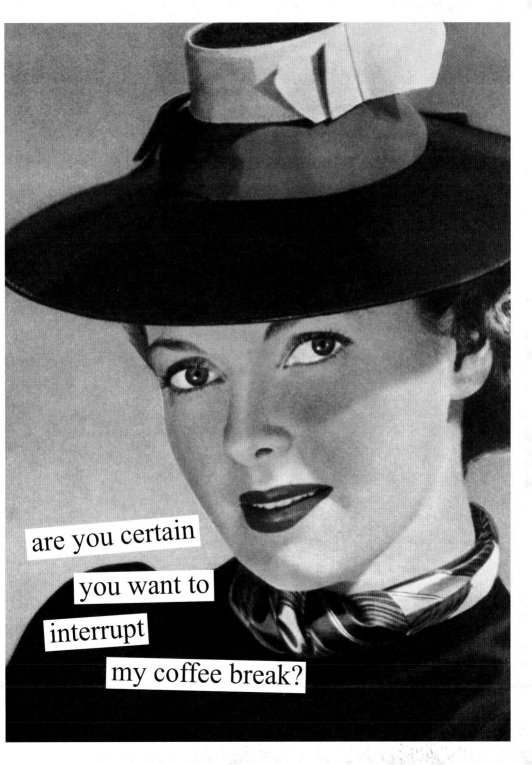

are you certain you want to interrupt my coffee break?

Money

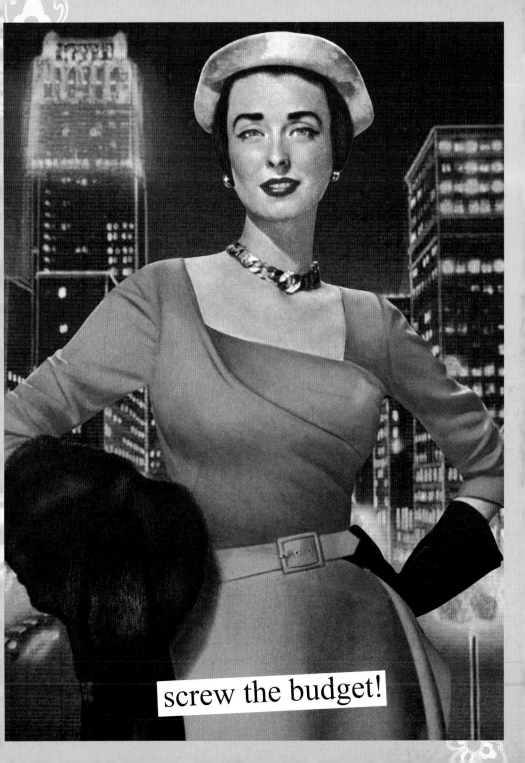

screw the budget!

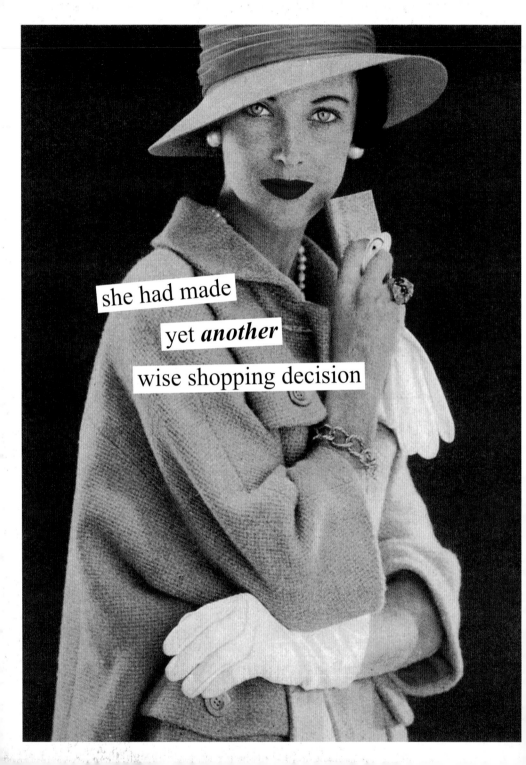

she had made

yet *another*

wise shopping decision

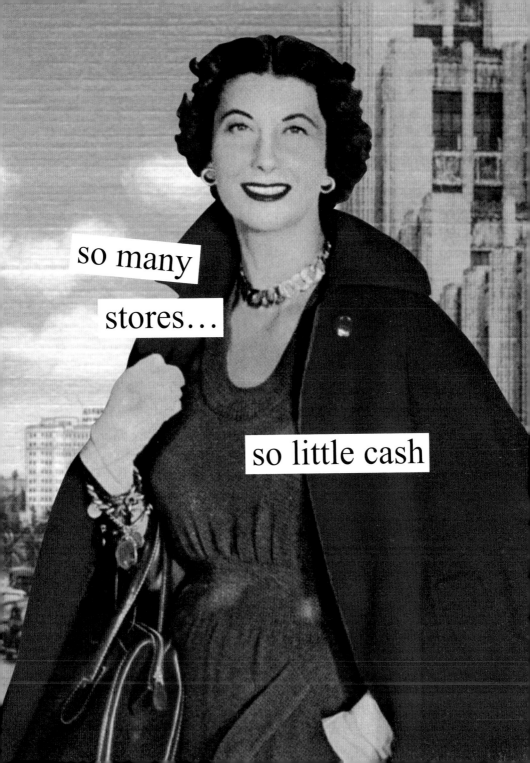

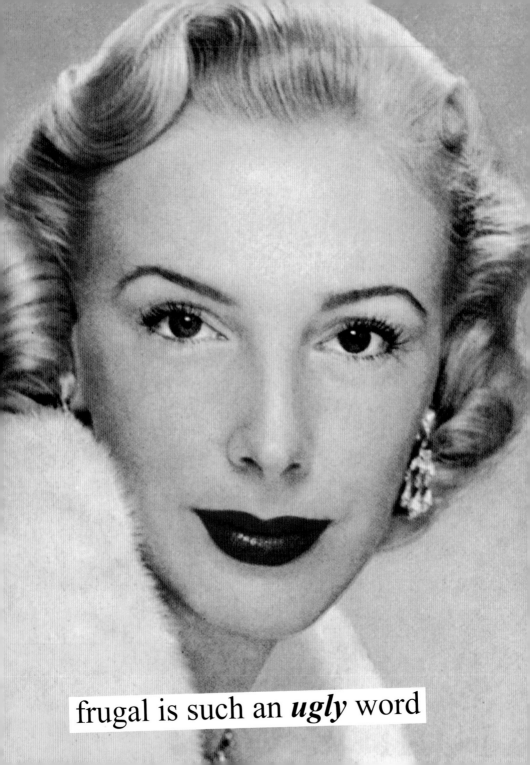

frugal is such an *ugly* word

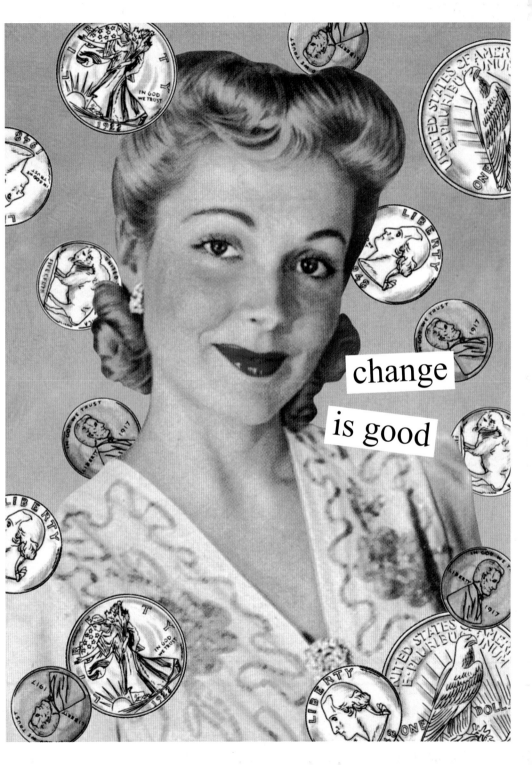

change

is good

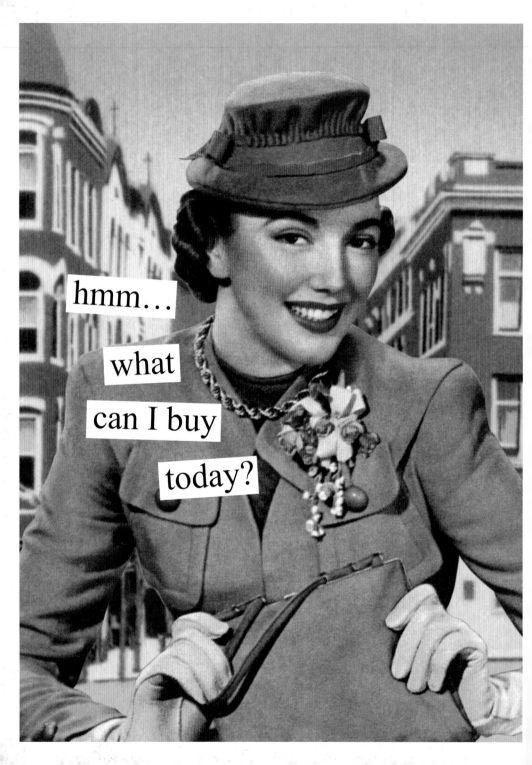

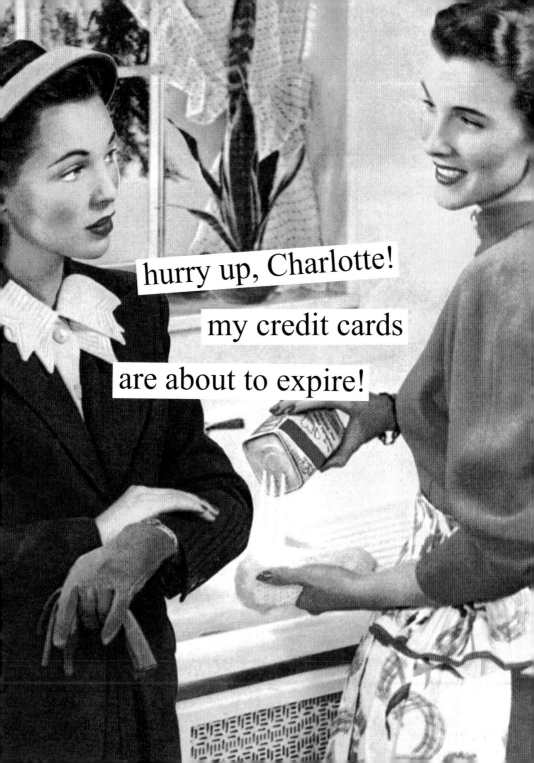

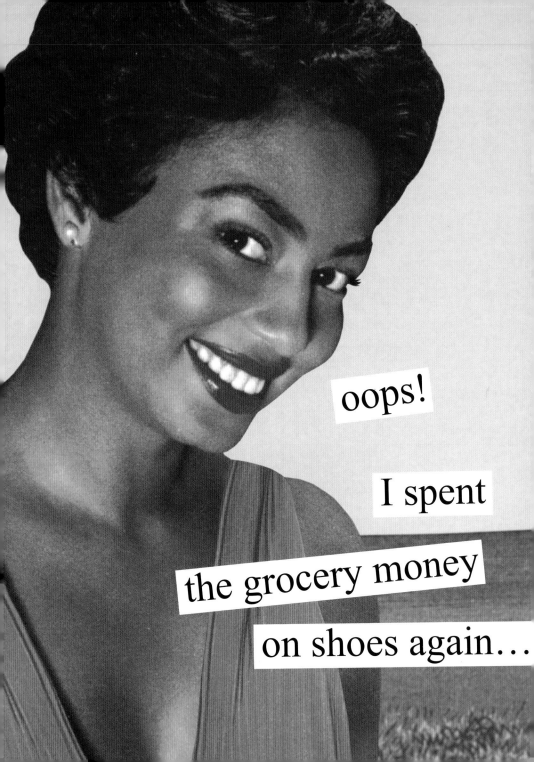

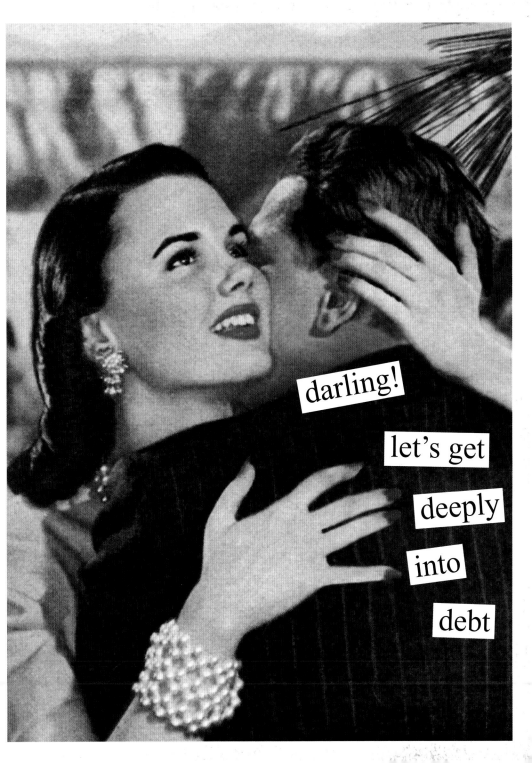

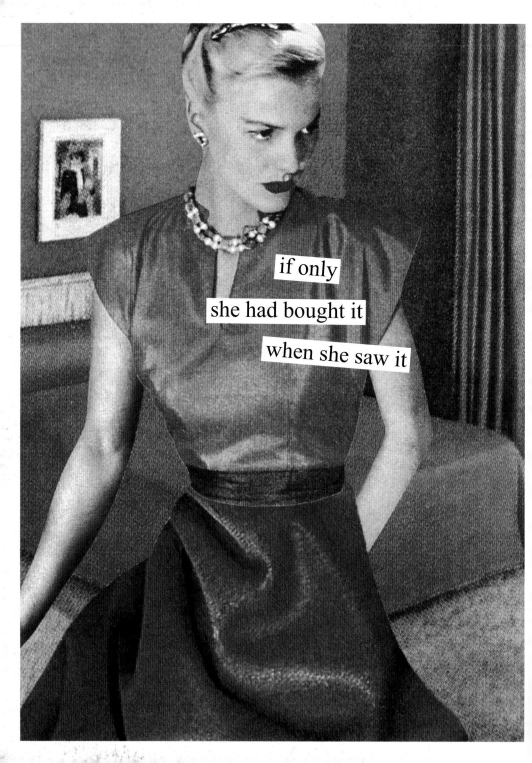

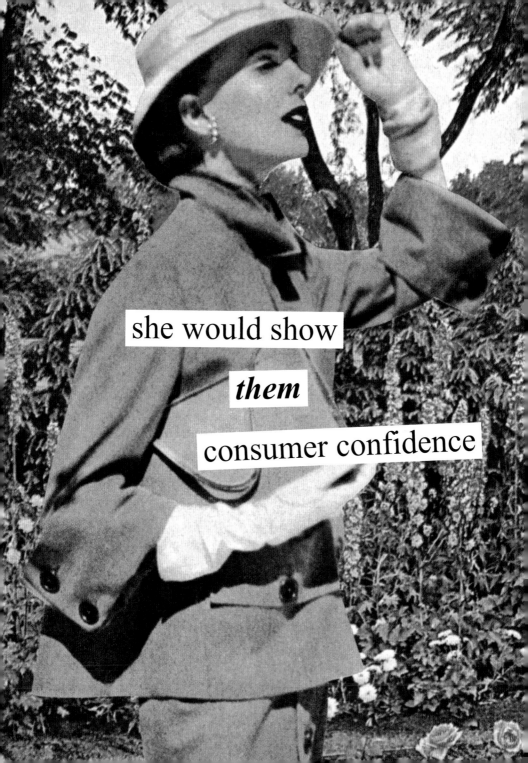

she would show

them

consumer confidence

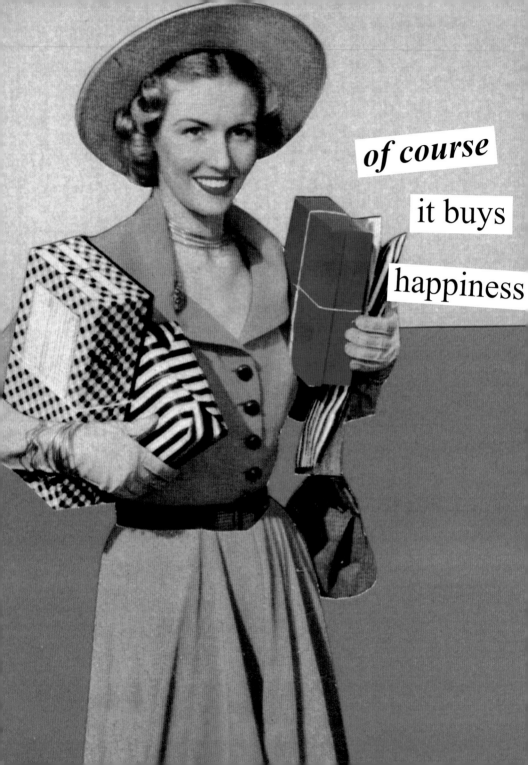

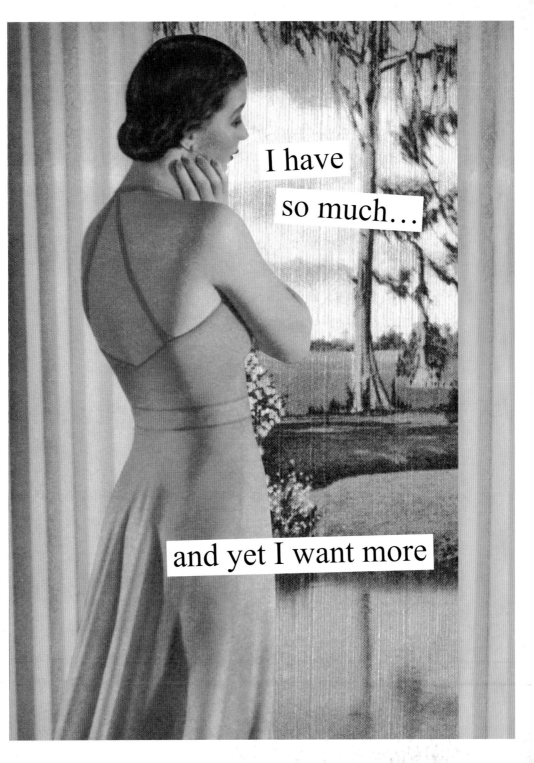

Cocktails

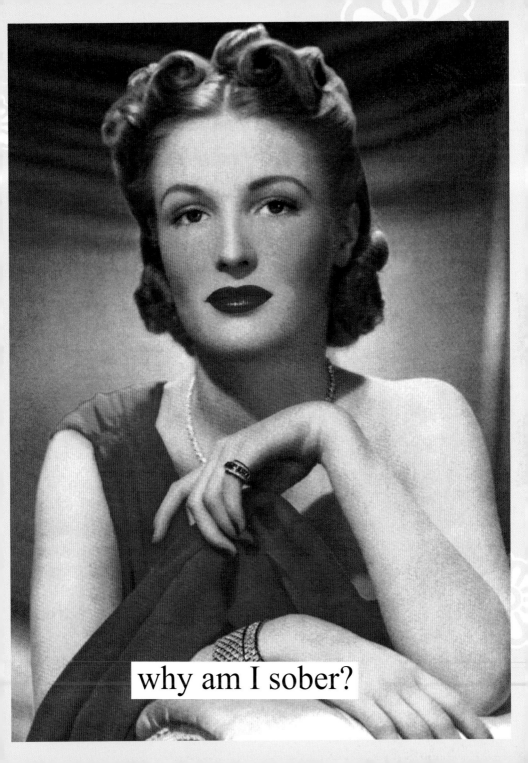

why am I sober?

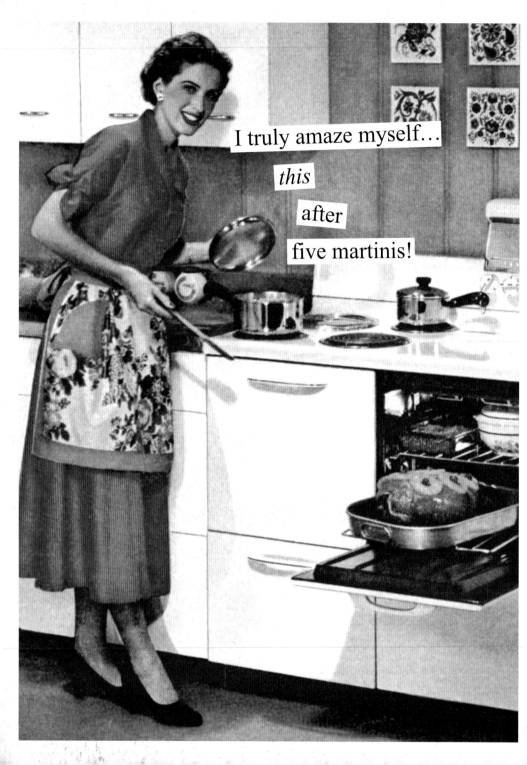

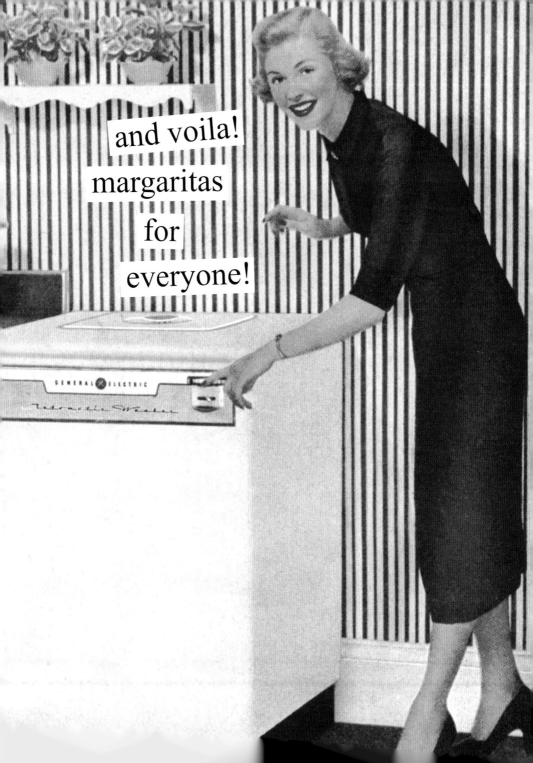

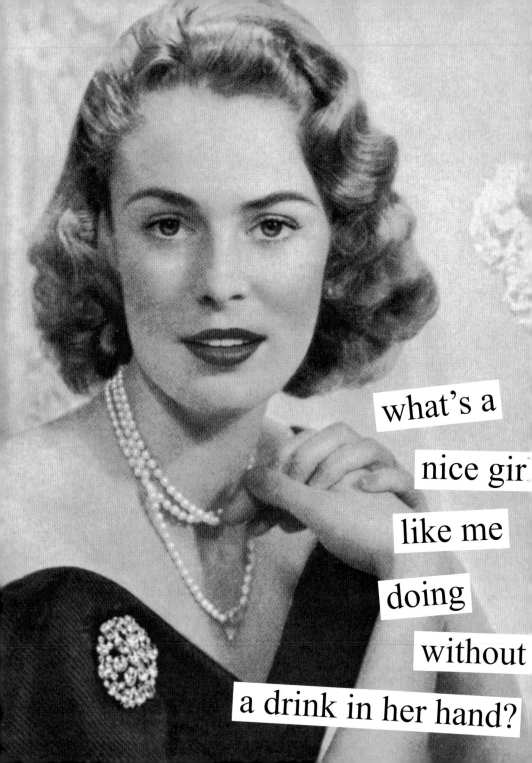

what's a
nice girl
like me
doing
without
a drink in her hand?

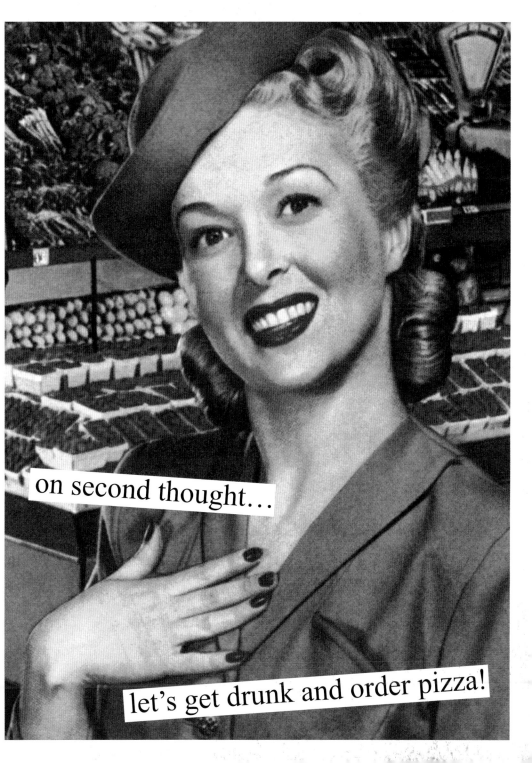

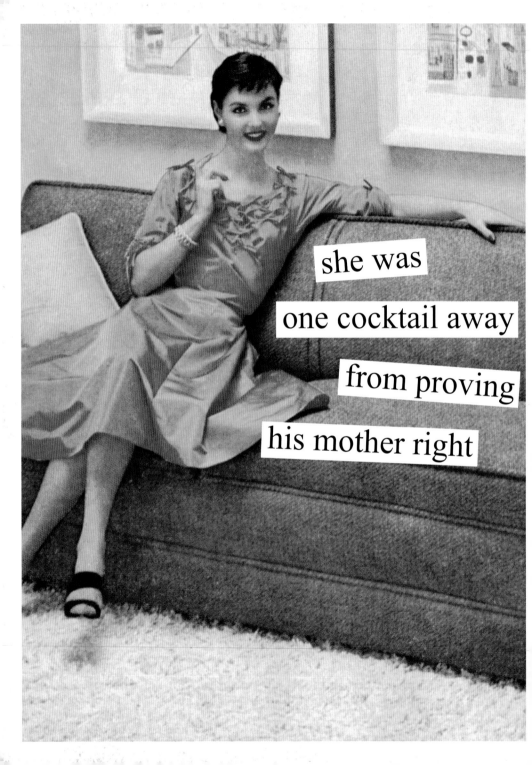

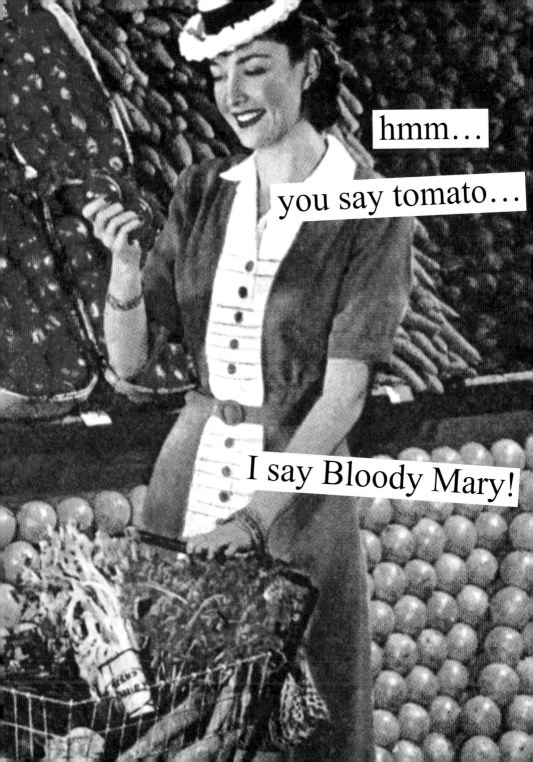

you have to start drinking

pretty damn early

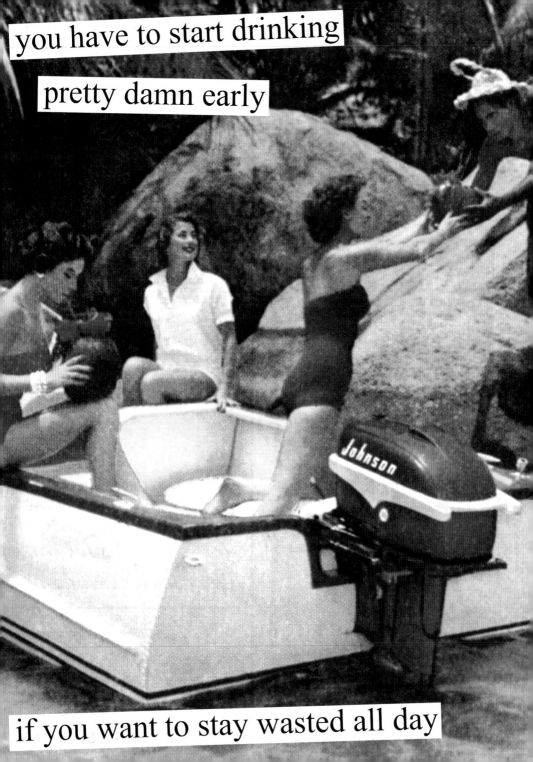

if you want to stay wasted all day

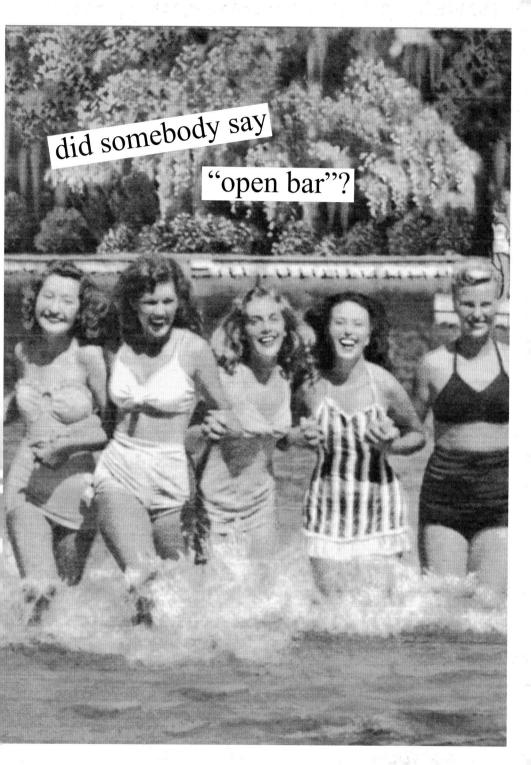

Can someone call the Coast Guard?

I believe I've dropped my Mai Tai.

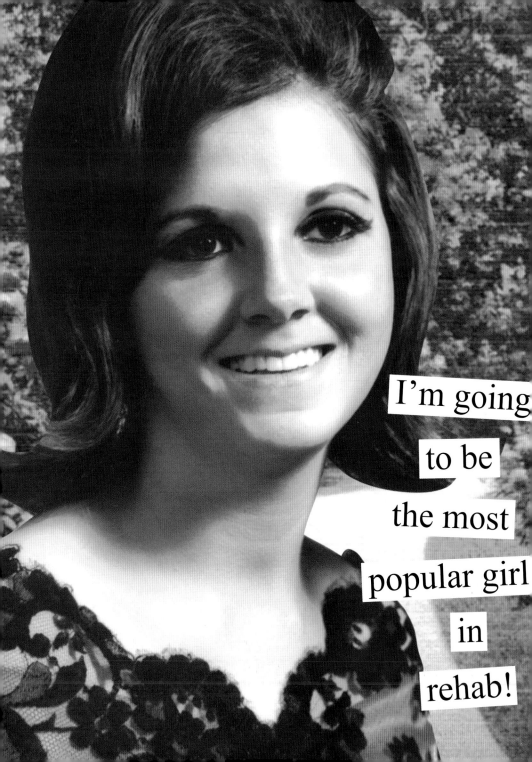

I'm going to be the most popular girl in rehab!

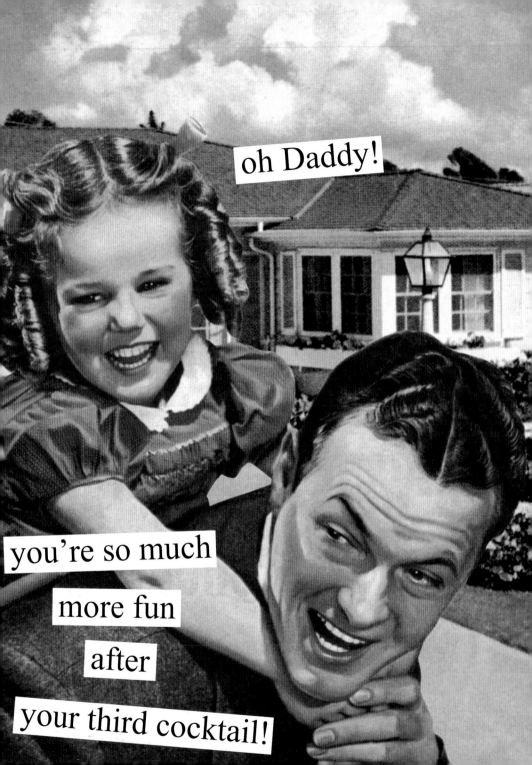

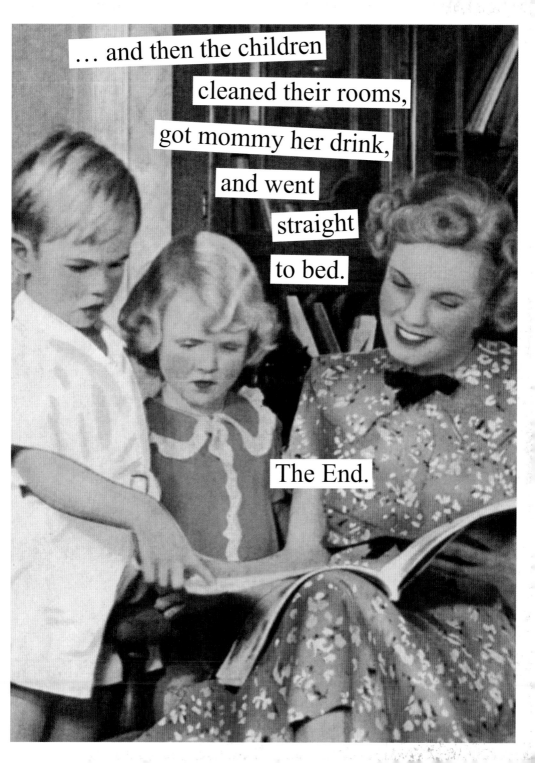

Travel and Leisure

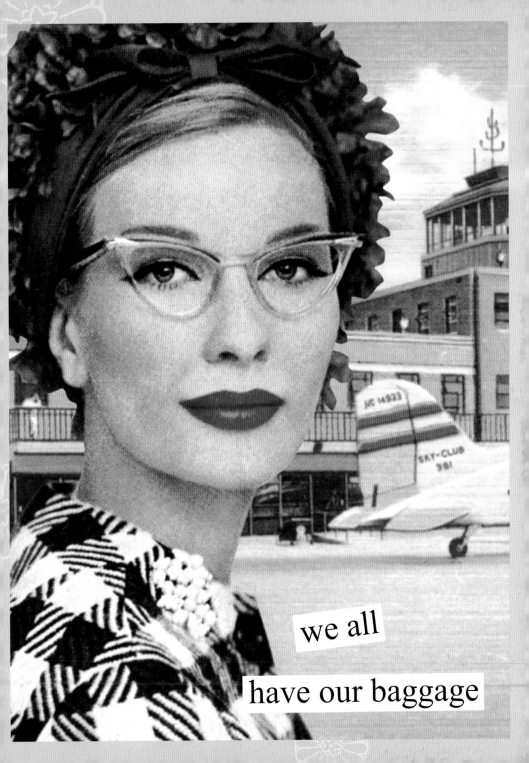

we all

have our baggage

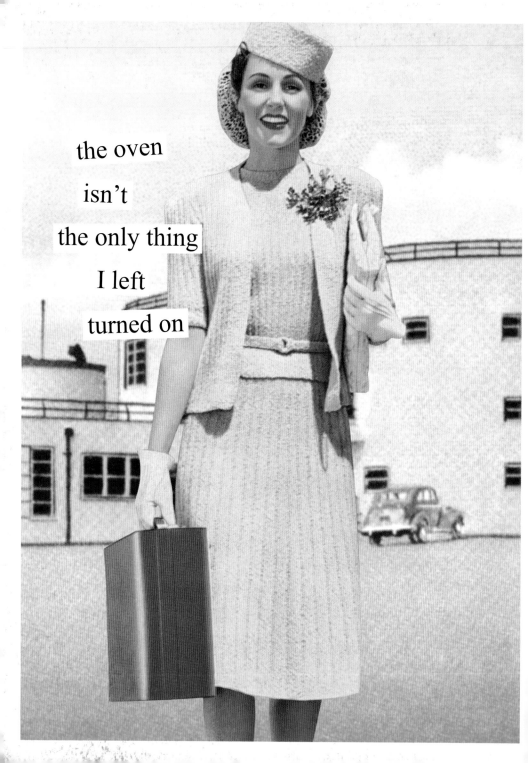

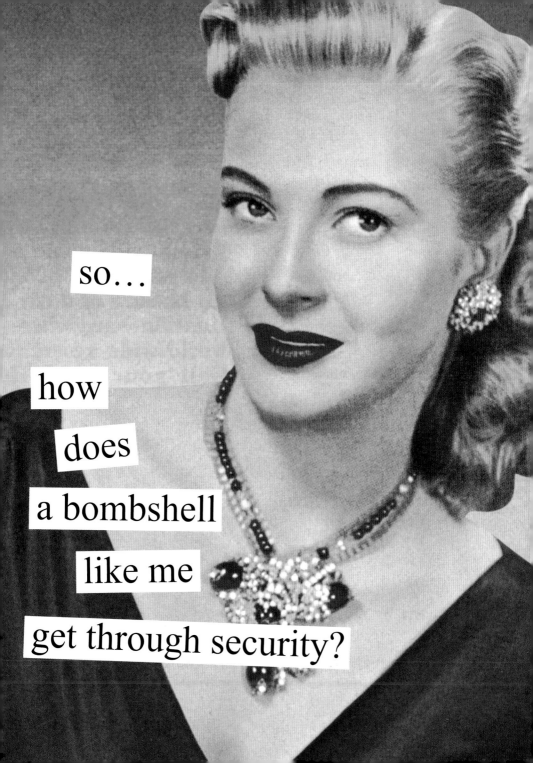

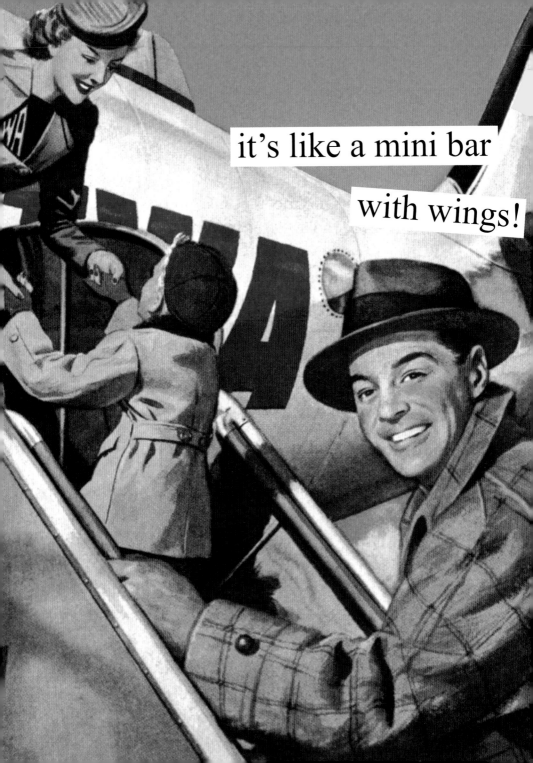

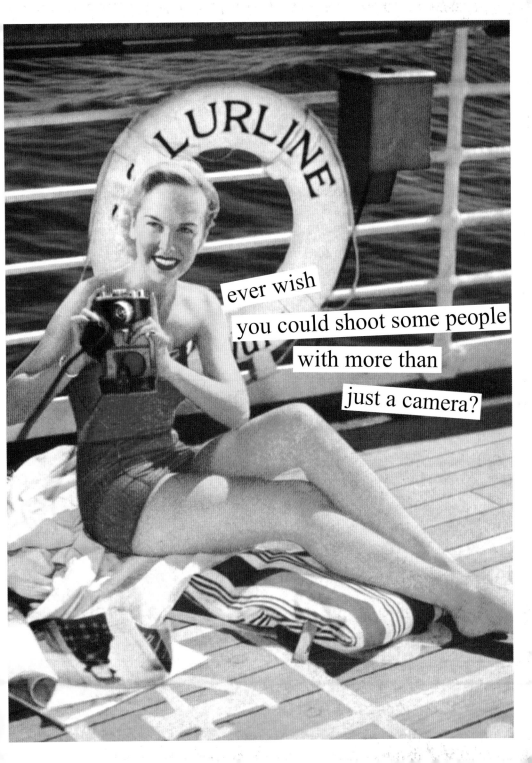

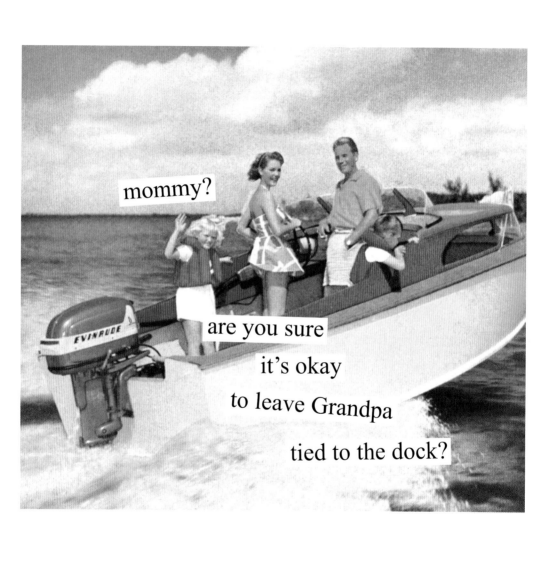

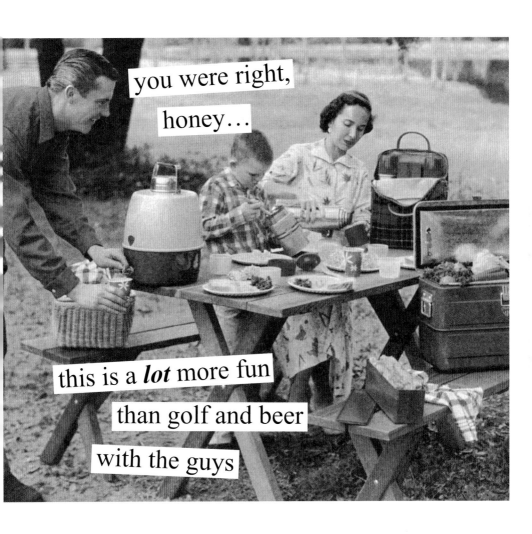

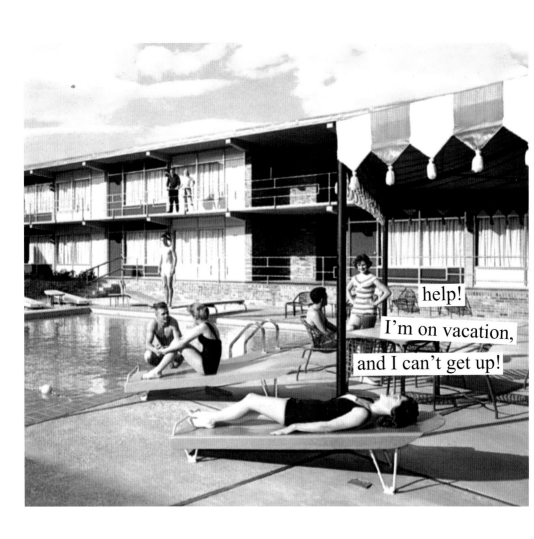

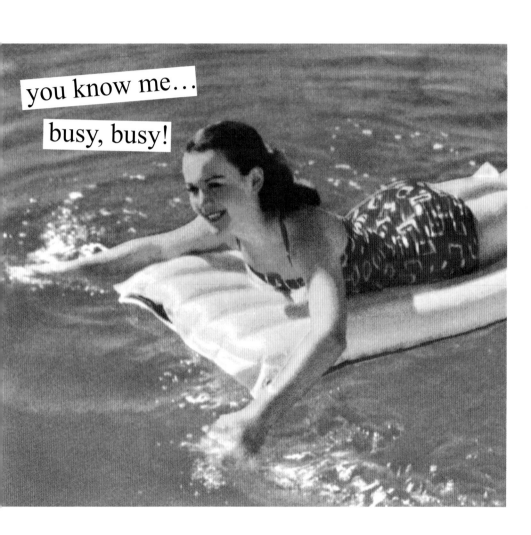

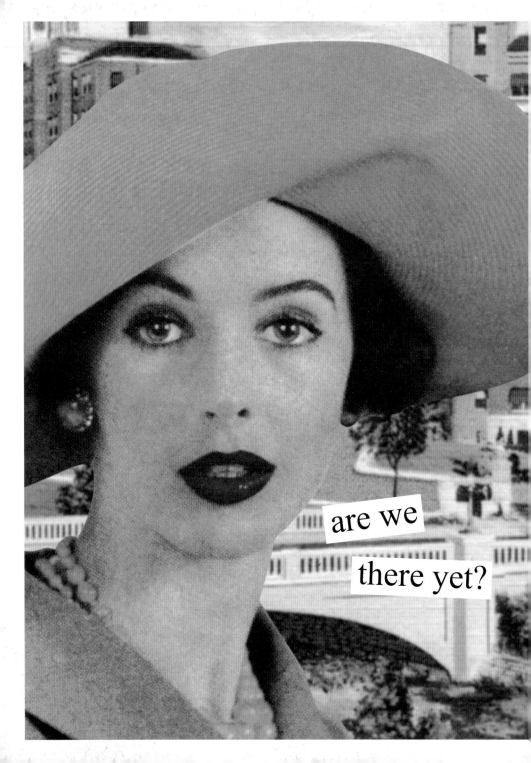

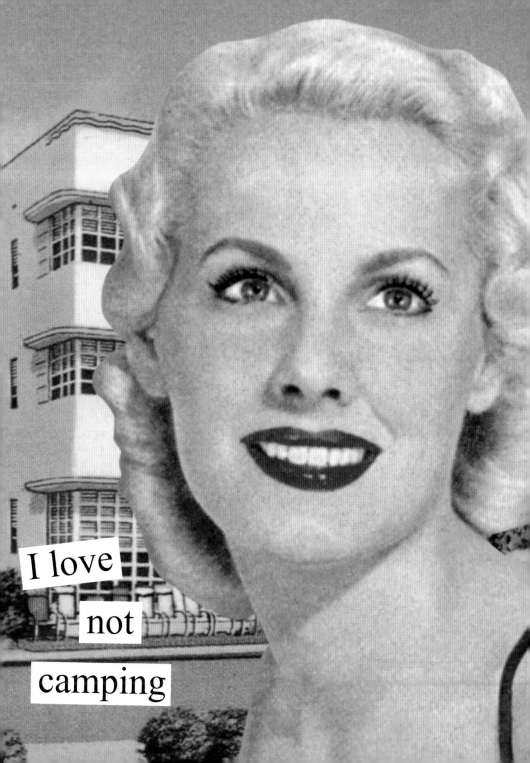

I love
not
camping

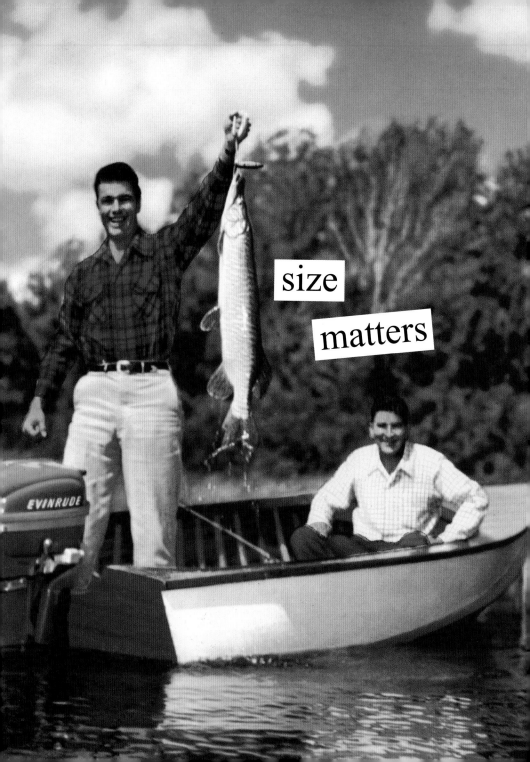

if by "having fun"

you mean trapped

with no means of escape…?

then yes,

we're having fun

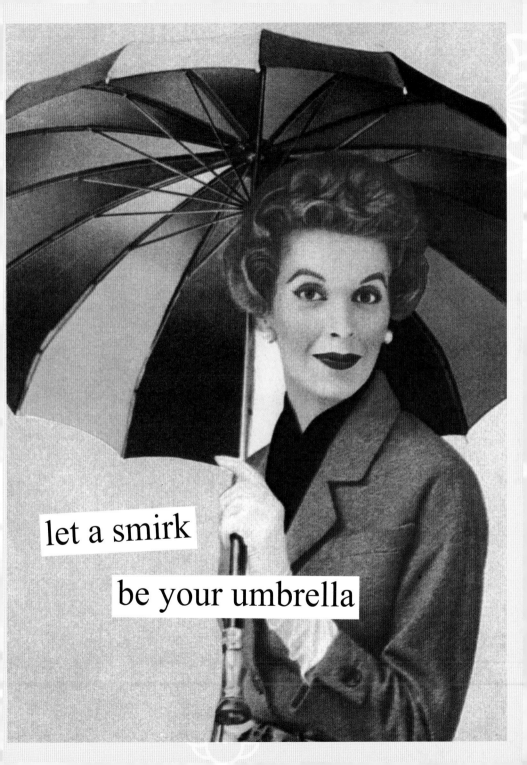

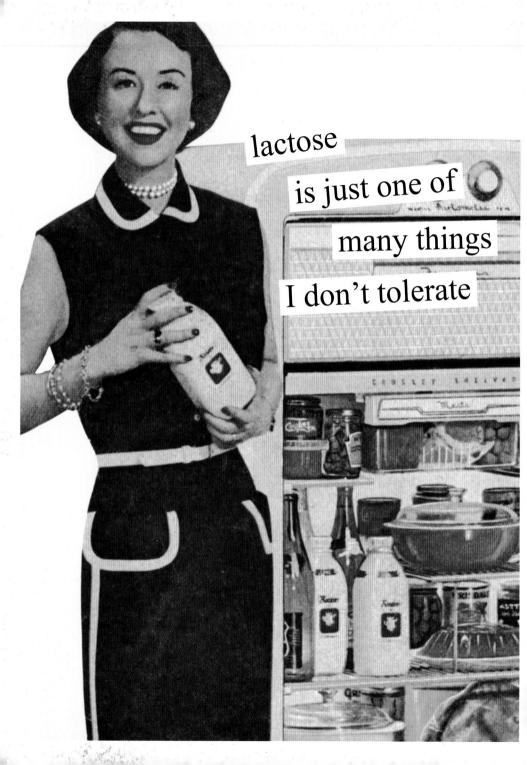

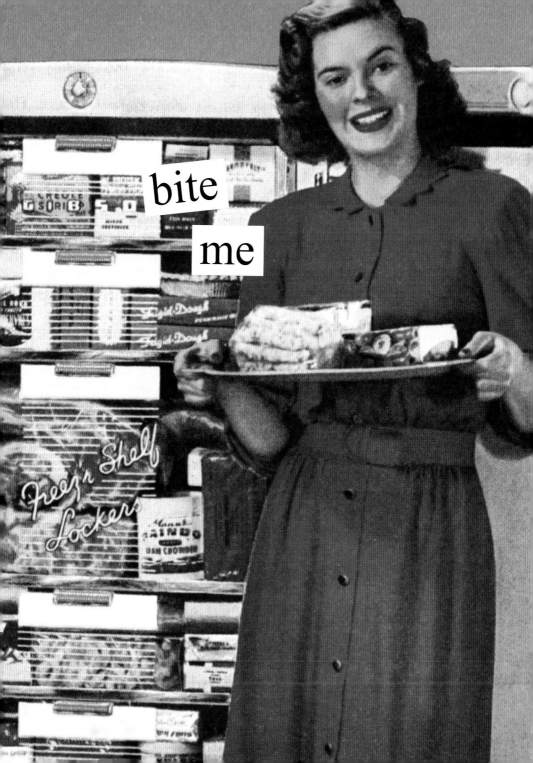

bite

me

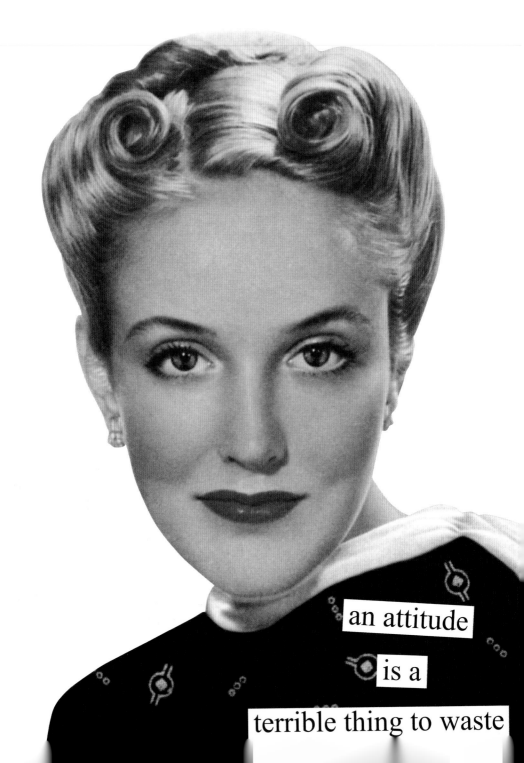

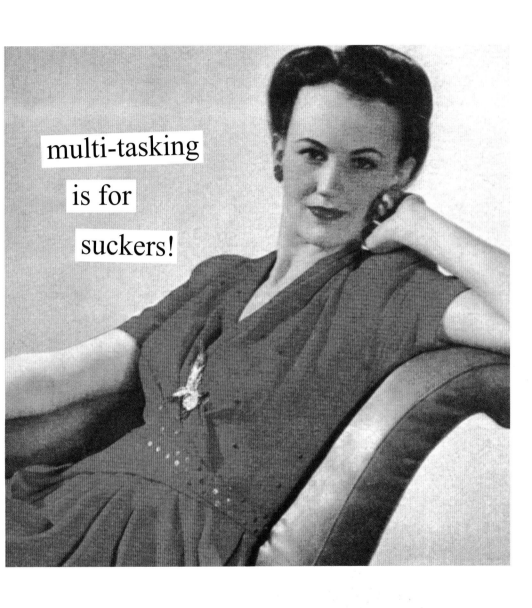

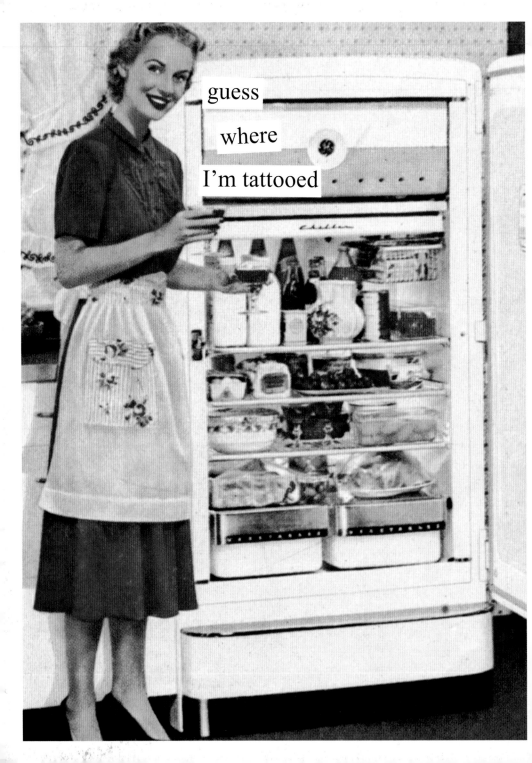

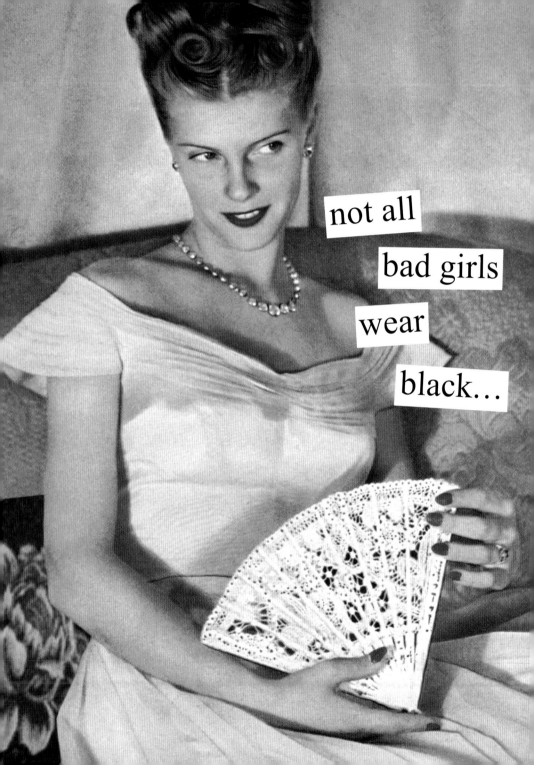

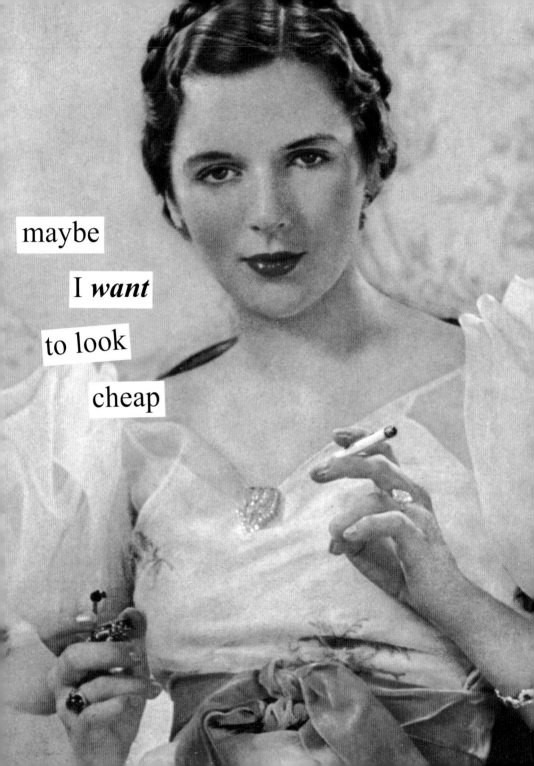

maybe

I *want*

to look

cheap

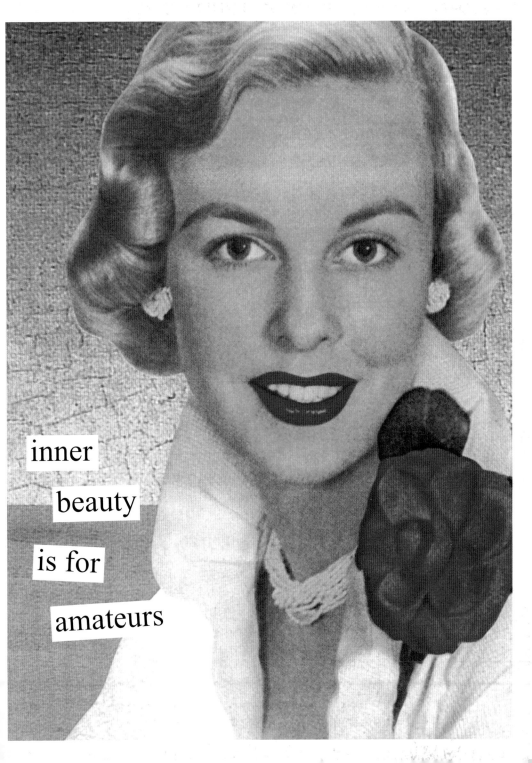

inner
beauty
is for
amateurs

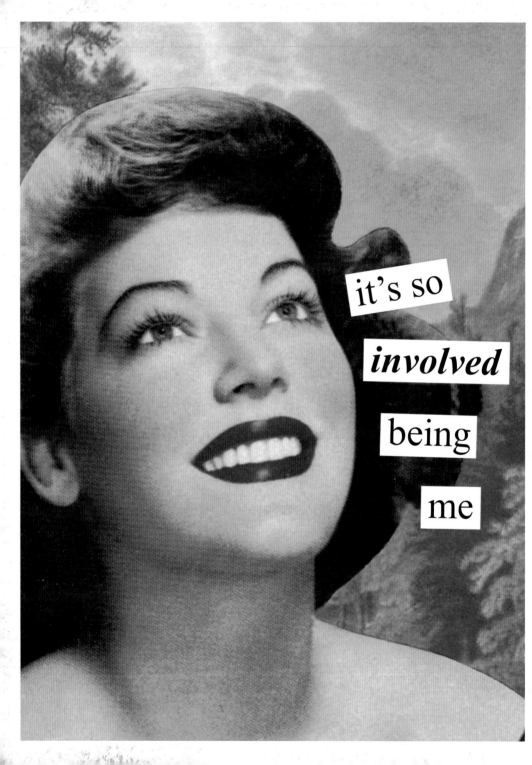

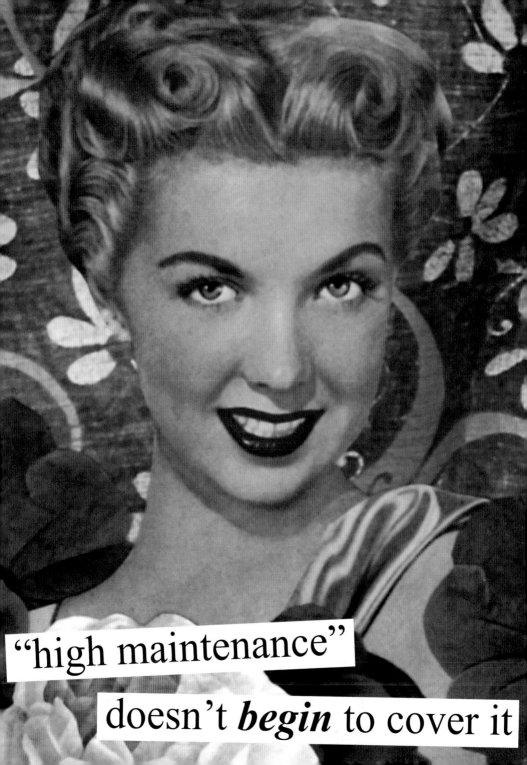

"high maintenance"
doesn't *begin* to cover it

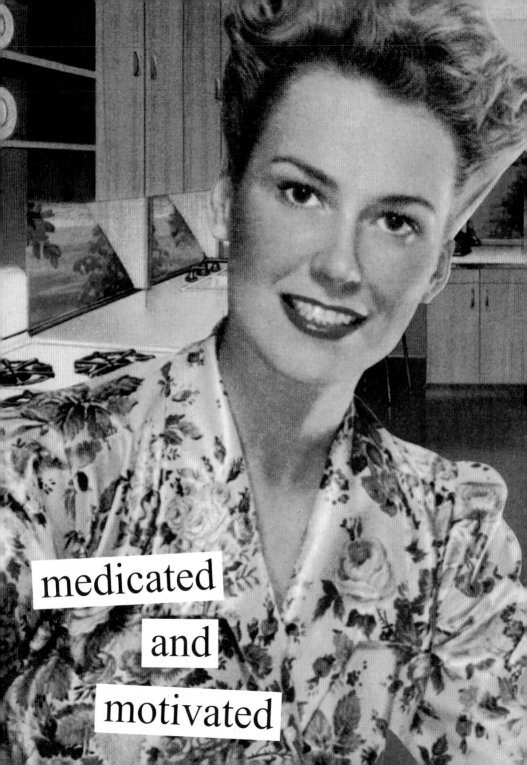

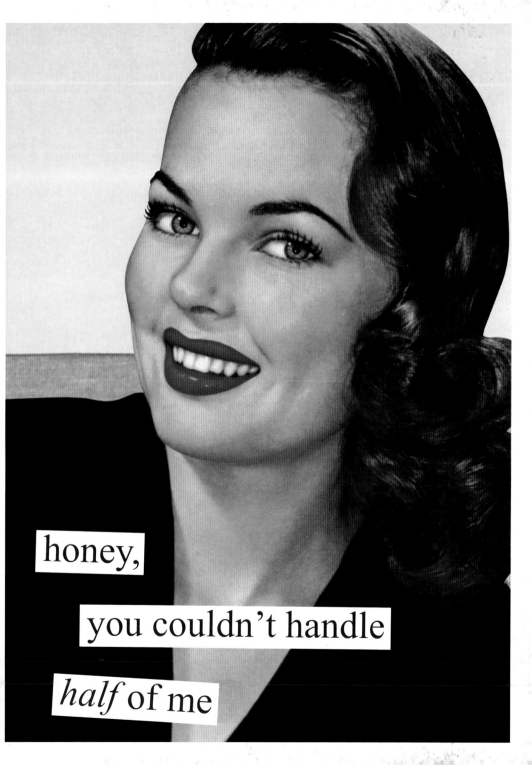

The

Woman of

Experience

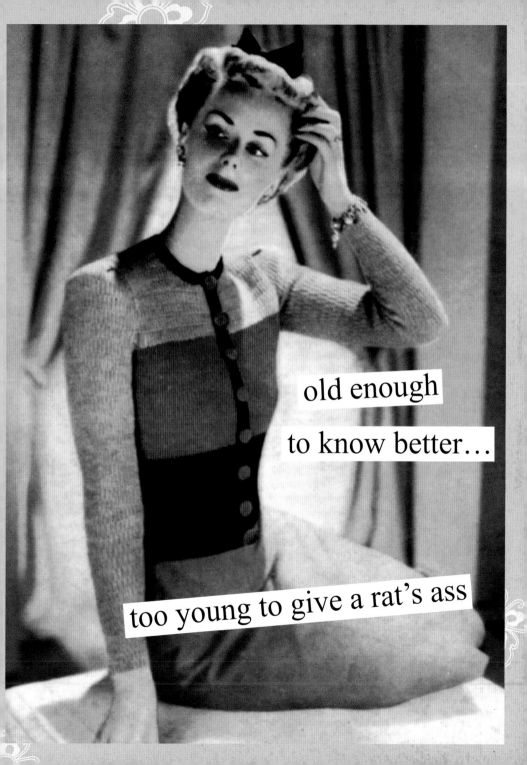

old enough

to know better…

too young to give a rat's ass

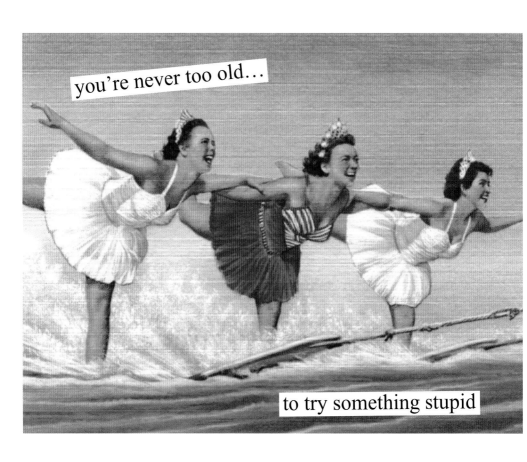

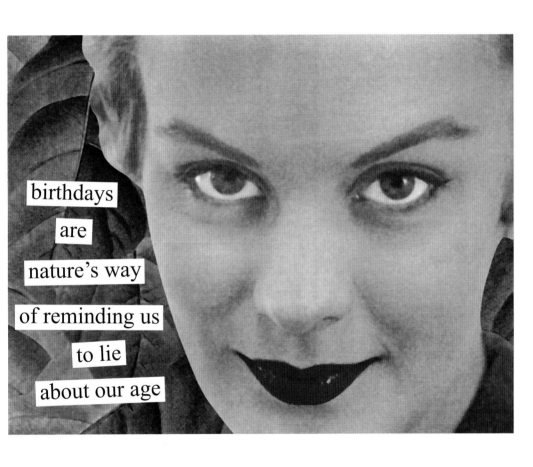

birthdays
are
nature's way
of reminding us
to lie
about our age

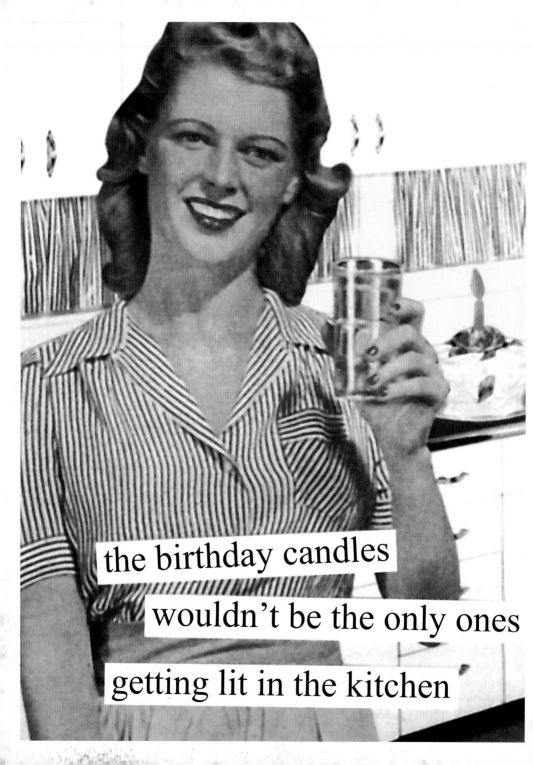

the birthday candles
wouldn't be the only ones
getting lit in the kitchen

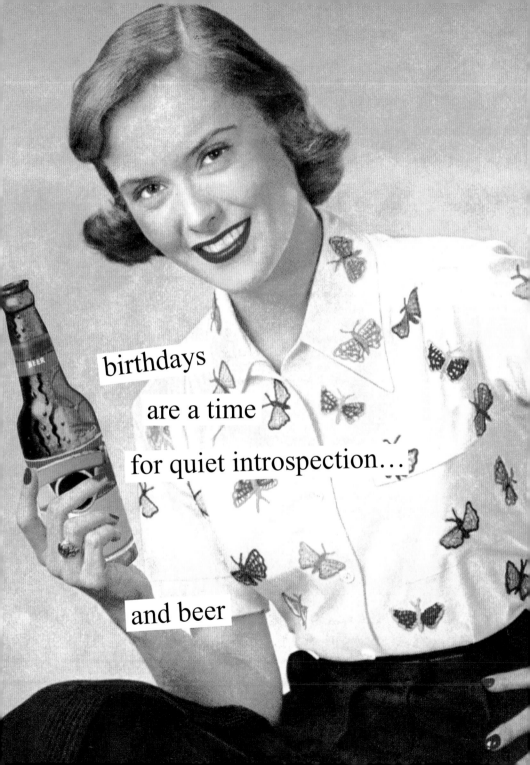

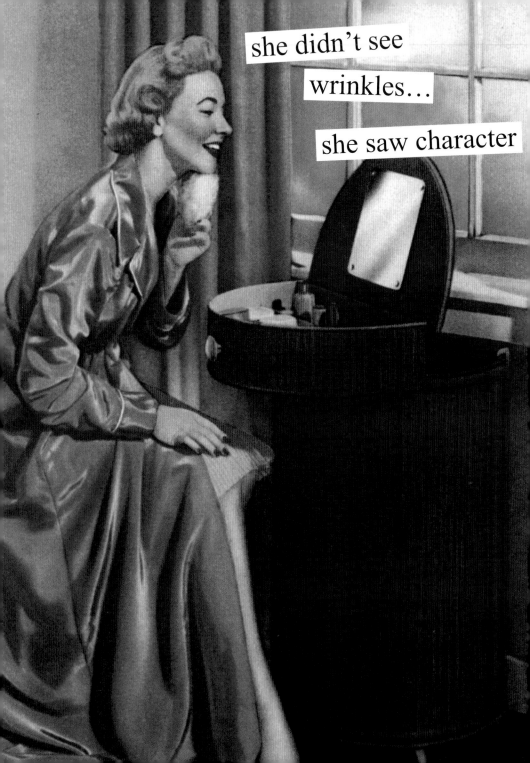

she was
beginning
to worry…

did she
look like a monkey?
did she *smell* like one *too?*

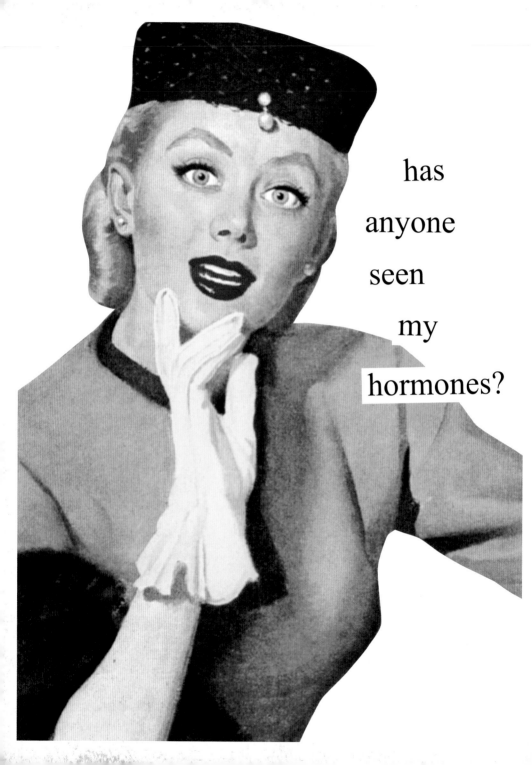

has

anyone

seen

my

hormones?

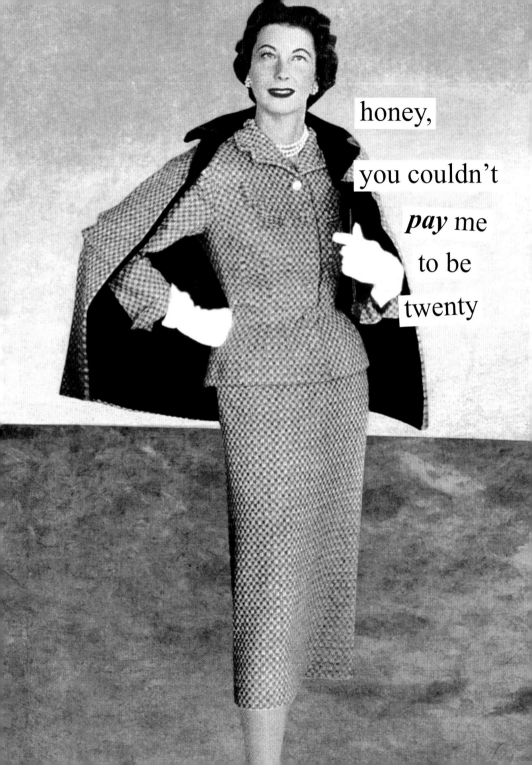

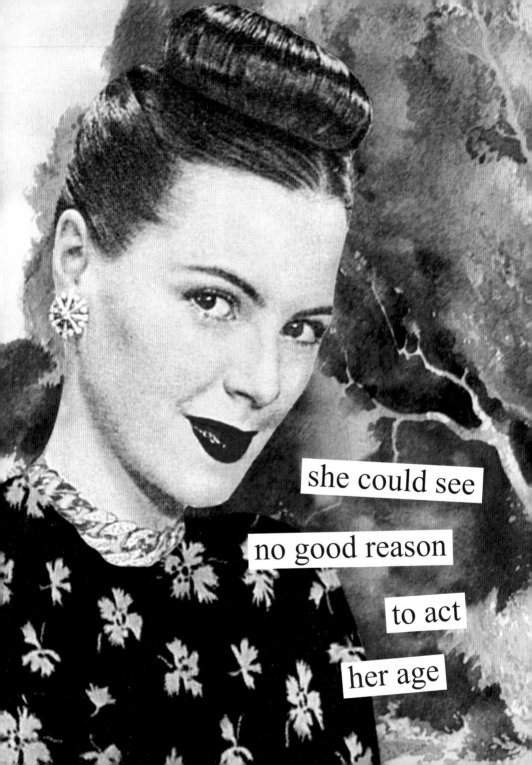

she could see

no good reason

to act

her age

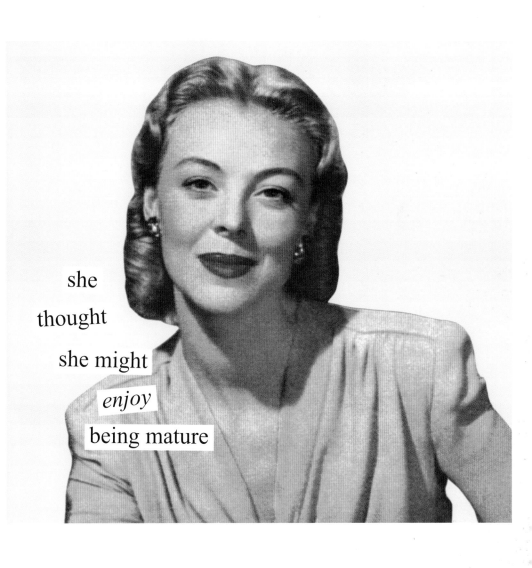

she
thought
she might
enjoy
being mature

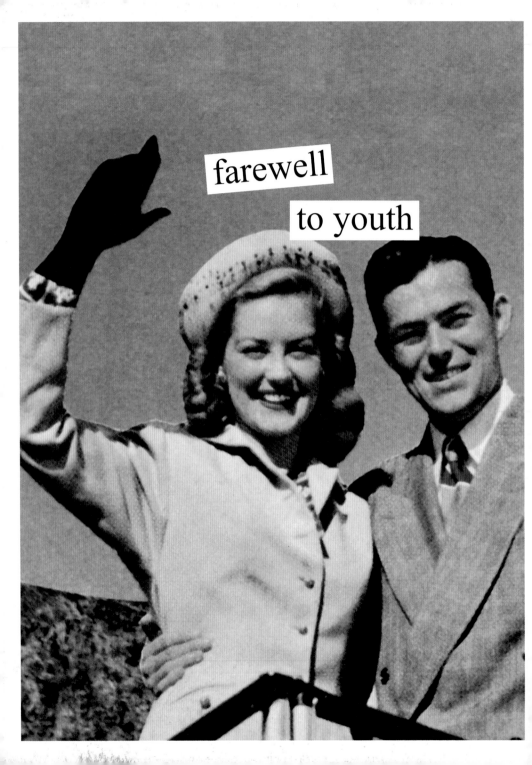

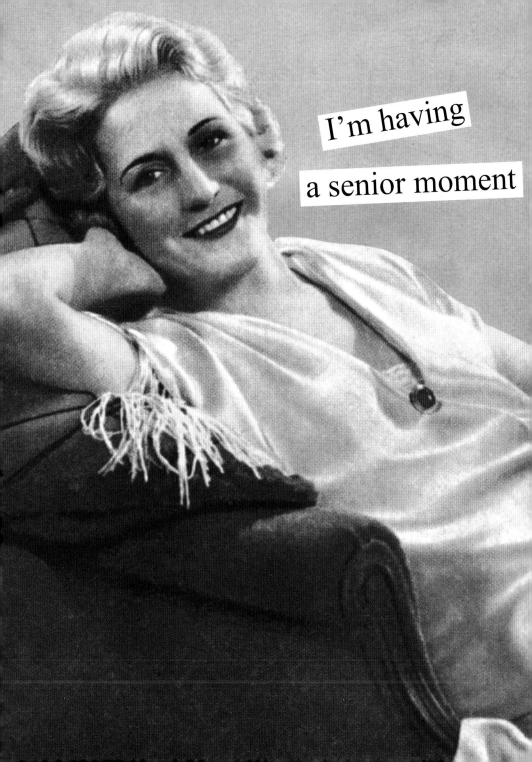

The
Holidays

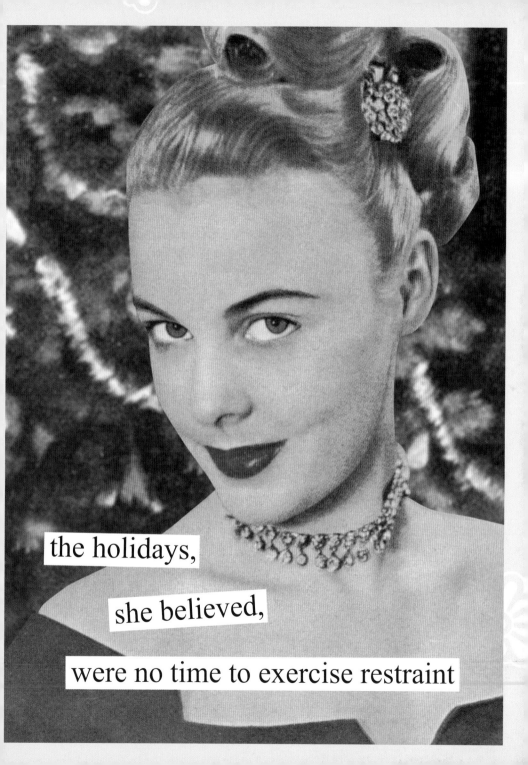

the holidays,

she believed,

were no time to exercise restraint

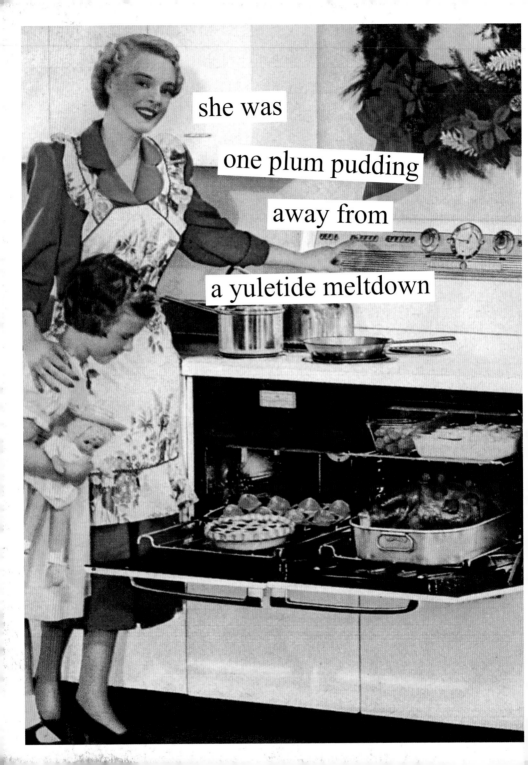

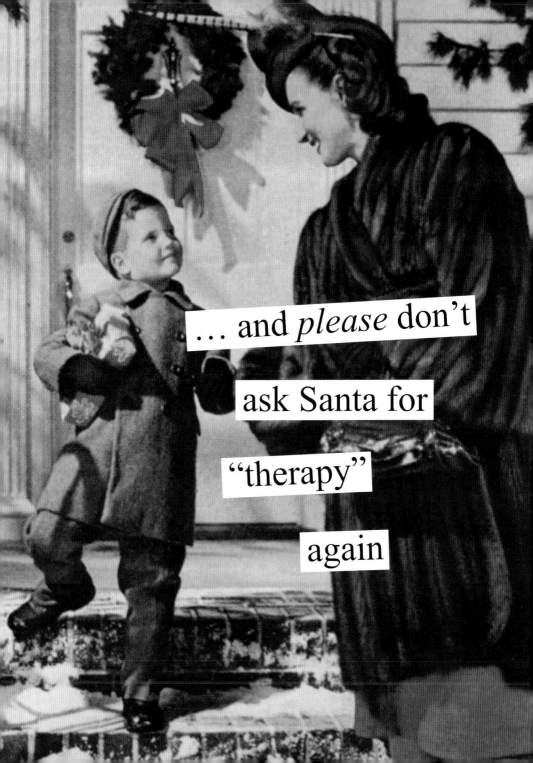

… and *please* don't ask Santa for "therapy" again

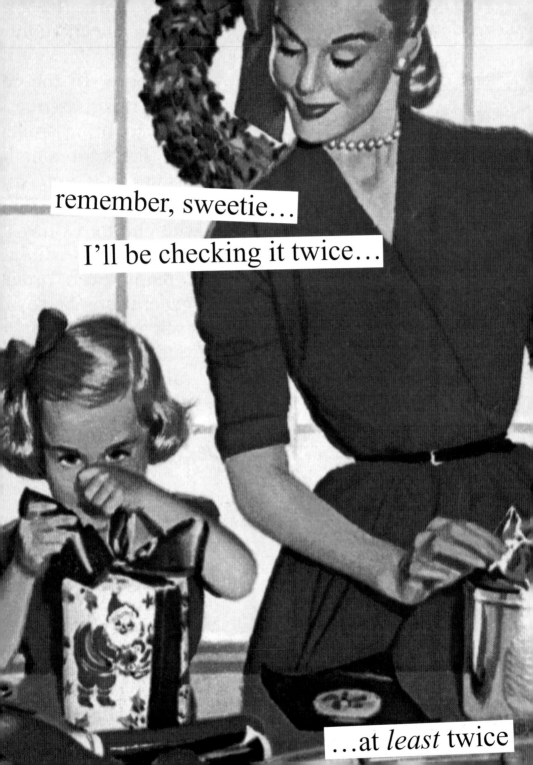

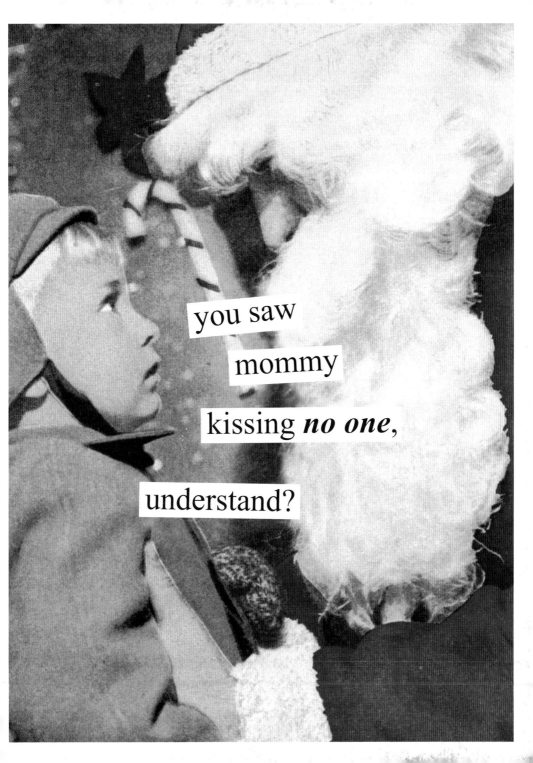

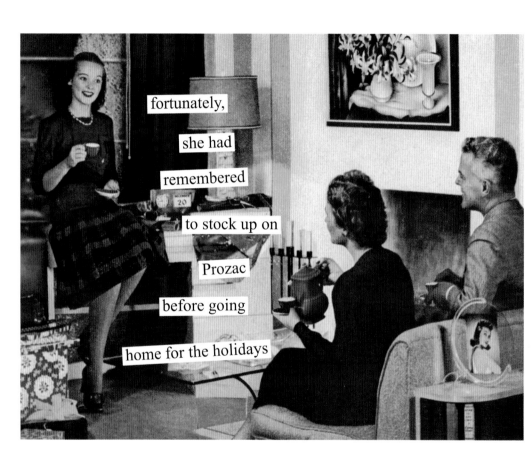

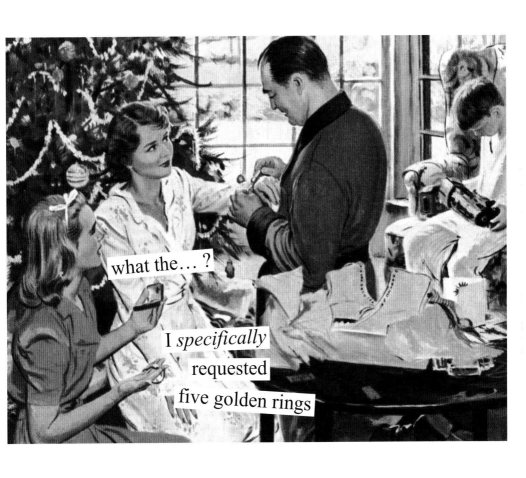

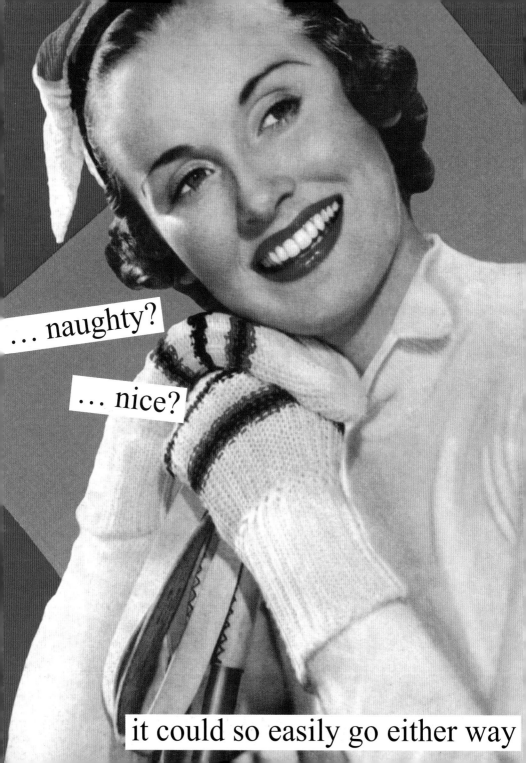

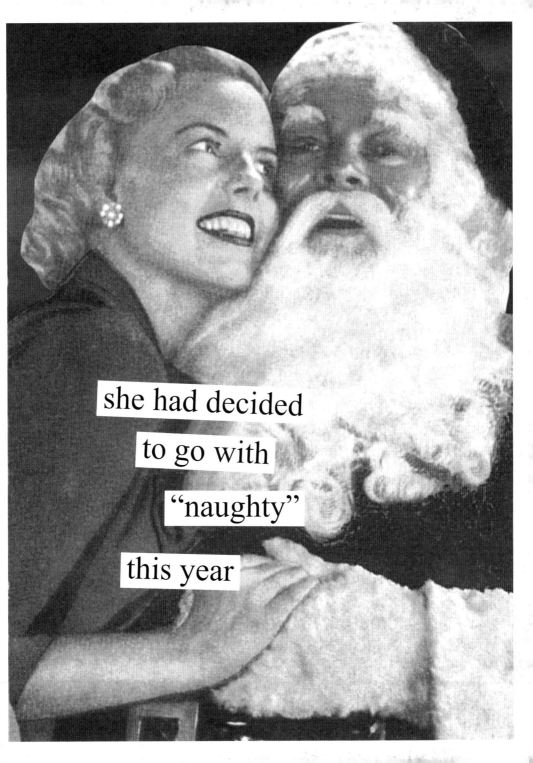

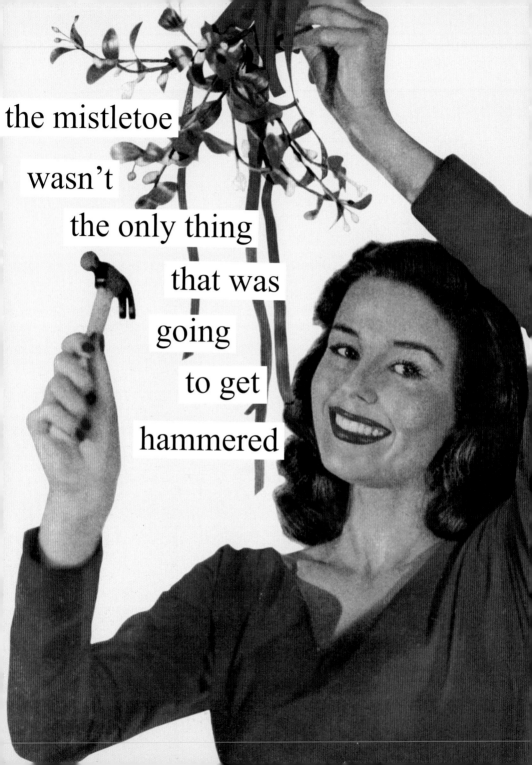

the mistletoe wasn't the only thing that was going to get hammered

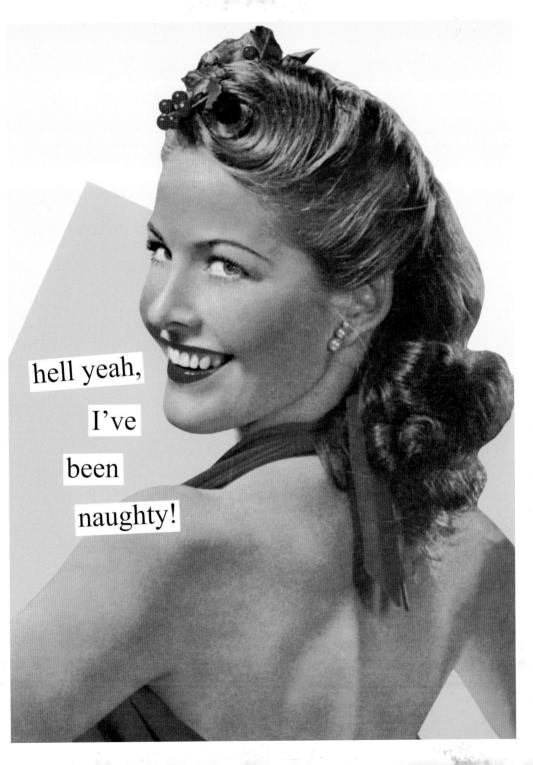

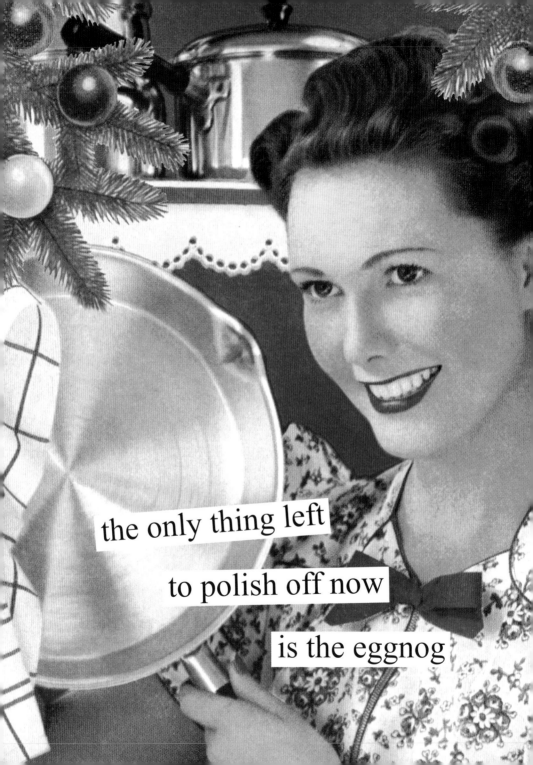

the only thing left

to polish off now

is the eggnog

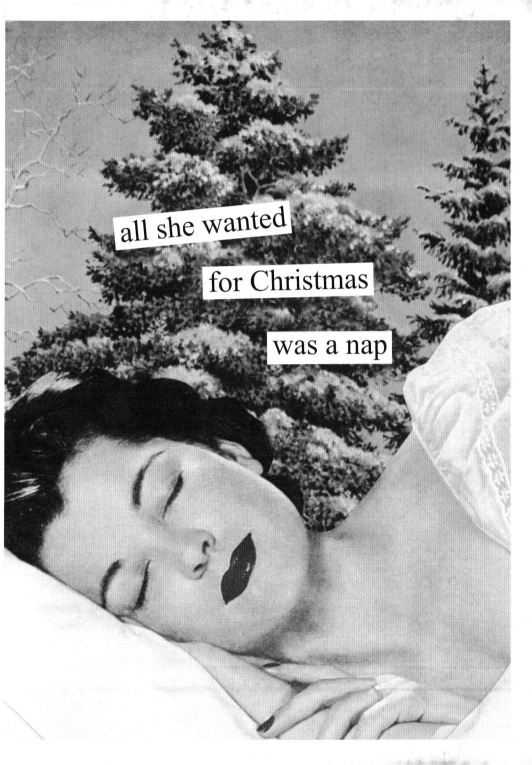

Also Available from Anne Taintor

I FEEL A SIN
COMING ON

Postcards

ANOTHER DAY IN
PARADISE…

Postcards

HMM…WHAT CAN
I BUY TODAY?

Journals

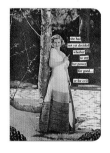

SHE HAD NOT YET
DECIDED WHETHER TO
USE HER POWER FOR
GOOD . . . OR FOR EVIL

Journals

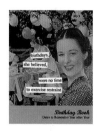

BIRTHDAYS, SHE
BELIEVED, WERE NO
TIME TO EXERCISE
RESTRAINT

Birthday Book

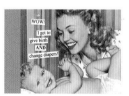

WOW, I GET TO GIVE
BIRTH AND CHANGE
DIAPERS?

Photo Album

See the full range of Anne Taintor books and gift products at

www.chroniclebooks.com